CONTENTS

ACKNOWLEDGEMENTS

Many thanks to all the individuals and organisations who assisted and granted permission to use maps and photographs, including: the National Archives of Ireland; the National Library of Ireland; the Irish Architectural Archive; the Valuation Office; Trinity College Map Library; Dún Laoghaire-Rathdown County Council; Sisters of the Sacred Heart; Little Sisters of the Poor; Dominican Sisters; Christian Brothers; University College, Dublin; The Fitzwilliam Museum, Cambridge; Simmons Aerofilms, England; Seamus Kearns, for postcards; Kevin Harrington; Scoil San Treasa; Peter Barrow Aerial Photography; Morrissey's Auctioneers; Finnegan Menton Auctioneers; Electricity Supply Board; and Biotrin.

1

FITZWILLIAMS

The Fitzwilliam family came to Ireland at the beginning of the thirteenth century, initially living in Ballymun in north Dublin. By the beginning of the fifteenth century, different family members were living in Donnybrook, Thorncastle, Merrion and Booterstown, the last of these having previously been the property of John Cruise and John de Bathe. In due course, the Fitzwilliams acquired large tracts of land in south Dublin and further afield, much of it granted by the King or Queen at a very low rent. At the height of their powers, their Dublin estate stretched from Ringsend to Blackrock, and inland to Dundrum and Ticknock. However, the Roebuck estate of Lord Trimleston cut into the Fitzwilliam estate at Old Merrion, stretching up to Mount Anville. Various branches of the Fitzwilliam family had castles at Dundrum, Baggotrath, Thorncastle and Old Merrion (between Ringsend and Blackrock). By the early eighteenth century, they abandoned Merrion Castle and built a new residence in the civil parish of Taney, naming the demesne 'Mount Merrion'. In 1865, the old site and about thirty acres of land was bought by the Sisters of Charity, who moved their 'St Mary's Asylum for Female Blind' here from Portobello House in Rathmines.

In 1629, Sir Thomas Fitzwilliam of Meryon was created the 1st Viscount Fitzwilliam. Oliver was the 2nd Viscount, William 3rd, Thomas 4th, Richard

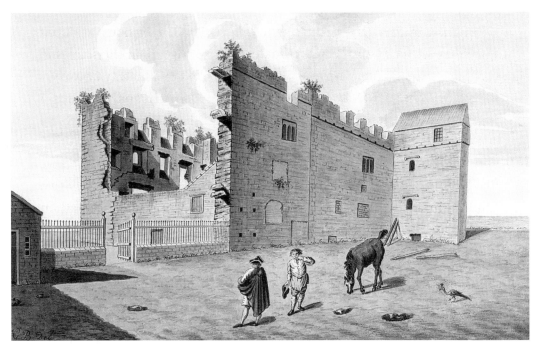

Merrion Castle was situated at the present junction of Merrion Road, Rock Road and Strand Road, where the Sisters of Charity have a convent. The castle was abandoned in the early eighteenth century. Painting by Gabriel Beranger, c.1766. (Courtesy of the National Library)

5th, Richard 6th, Richard 7th, and John 8th, upon whose death, in 1833, the viscountcy became extinct. However, most of the family property had been bequeathed in 1816 by the 7th Viscount to his cousin George Augustus, Earl of Pembroke and Montgomery, and thereafter the estate was known as the Pembroke estate. Historians recall that in 1169, Richard de Clare, Earl of Pembroke, otherwise known as Strongbow, arrived in Ireland at the request of Diarmuid, King of Leinster, married Diarmuid's daughter Aoife as a reward, and then, King Henry II started the conquest of Ireland. Some of the Fitzwilliams are buried in Donnybrook graveyard.

There was no such townland as Mount Merrion, but the townland of Owenstown (100 acres) corresponds partly with the present layout. In later years, Mount Merrion was also known as Callary.

The Fitzwilliam family are thought to have built their new home in Mount Merrion around 1711, because a datestone was found on the stables in recent decades and has now been fixed to the present Community Centre. By this stage, Richard, 5th Viscount Fitzwilliam, had converted from Catholicism to Protestantism, in order to take his seat in the Irish House of Lords; 'he conformed to the Established Church', to use the phraseology of the day.

A map of the estate by Cullen, dated 1722, shows a large, two-storey, five-bay house directly opposite the main east avenue, flanked by two smaller, three-bay houses. However, when Dublin land surveyor Jonathan Barker surveyed the property in 1762, his map shows all the original buildings demolished and replaced by a different layout, with the main house on the north side of the avenue, and extensive stables and farmyard on the south side, but nothing facing down the east avenue towards the sea at Blackrock. The new house was built as a north and south wing connected by a long passage, with kitchen and servants' quarters in the north wing. Therefore, the datestone of 1711 is not original to the stables, and was probably on the original house facing down East Avenue.

Barker calculated eighty-four acres in the demesne, and listed various buildings and fields as follows: new kitchen, kitchen yard, new stables, hackney stables, hen yard, working shade for stone cutters, cow house, cow yard, horse pond, dung yard, ash grove including vistos (south of stables), pleasure garden with terrace walks, elm wilderness (west of stables), lawn at back of house, Scotch fir grove, with octagen shell house in centre supported on stone pillars and thirty-two vistos corresponding with the points of a mariner's compass (now Deerpark Wood), furry park, Owenstown meadow, wood field, well meadow, rushy field, shelly field, St Patricks field (north-east of demesne), quicken park, shoulder of mutton meadow, pigeon park, lower slang, upper slang (both previously called long meadow, and now site of Trees Road), and quarry field.

Within a few years of Barker's map, an extension had been added to the front of the house (the south side of the south wing), but the design was in poor contrast to the original house.

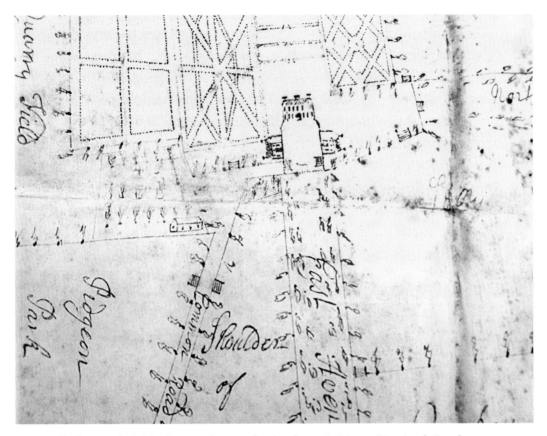

Cullen's map of 1722, showing the main five-bay house in Mount Merrion facing the driveway (East Avenue), flanked by two smaller three-bay houses. (Courtesy of the National Archives, Pembroke Estate, 2011/2/1/7)

The eighteenth-century demesne initially extended only to the present Roebuck Avenue, and not to Foster's Avenue, and did not include a deerpark to the west of the woods. The 6th Viscount Fitzwilliam is credited with forming this deerpark in the years preceding his death in 1776.

By the time William Ashford sketched the layout of the demesne around 1805, the property extended as far as Foster's Avenue and westward to Mount Anville estate. By 1831, a new deerpark had been added (the area around the present Cedarmount Road, which was known as Callery, and originally the property of Viscount Allen). Ashford depicts the residence

as being two distinct buildings, the main one (showing the new south extension, with most of the original house obscured by trees) and a separate north wing, which was the servants' quarters, all described as The Lodge. This implies that the estate was being used as a hunting lodge; hence the house was quite small compared to the seats of other important landowners. In fact, the Fitzwilliams rarely lived there, since their main residence was in Salisbury, England, and they usually rented out the house from year to year, while maintaining control over the surrounding land. The extensive stables, a short distance to the south of the main house, pointed to hunting activities, and the farmyard adjoining the stables shows

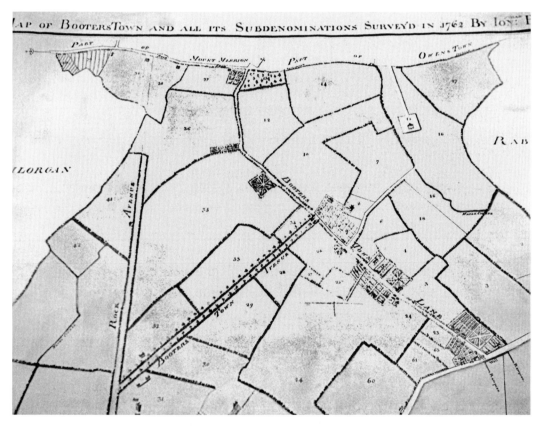

Barker's 1762 map of Booterstown. The west end of Mount Merrion Avenue is not yet completed. (Courtesy of the National Archives)

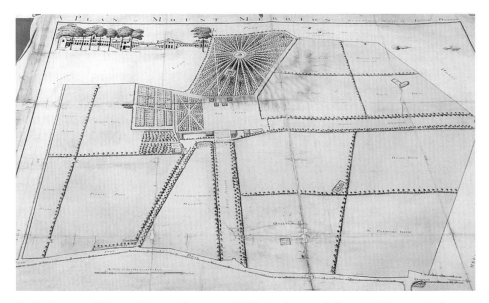

Barker's map of Mount Merrion demesne, 1762. At the top of the main driveway is the house, with two wings, and the stables and farmyard to the south of the house. (Courtesy of the National Archives, Pembroke Estate, 2011/2/2/11)

that the estate was used partially for farming purposes (hen yard, cow yard, dung yard, horse pond, etc).

The stable block (a large part of which is still in use as offices, at No.93 The Rise), is shown on an 1831 map as having residential accommodation near the south end of the main building, and likewise there is a small residence attached to one of the glasshouses in the extensive gardens. The north wing of the stables facing the main house was nearly as imposing as the house, and may have been used as steward's quarters at a later date, although a chief steward's house was erected in the gardens in the 1890s and is now in use as a private house (No.29 Trees Road). Over the years, the two wings of the main house were substantially united, as extensions were built between them.

As previously stated, the Fitzwilliams mainly occupied Mount Merrion House, for short periods or special occasions. One exception, however, was Richard, 6th Viscount Fitzwilliam, who died in the house in 1776 after

carrying out various improvements to the estate. The Fitzwilliams let the house to important people, such as the Honourable John Wainwright, Baron (Judge) of the Exchequer in the 1730s, then to the Lord Chancellor Robert Jocelyn in the next two decades. The accounts show that the Chancellor paid annual rent of £34 10s and that he vacated the house in 1756. John La Touche occupied it for a few years in the early 1780s, at a rent of £162 per annum. Another notable in Mount Merrion House, from 1786 to 1793, was the Attorney General, the Right Honourable, John

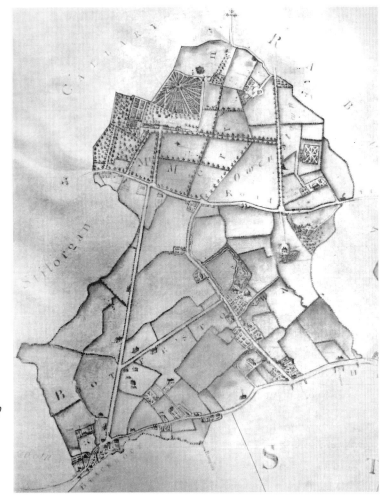

Roe's 1774 map, with Mount Merrion demesne at the top and Booterstown below. By now, the top of Mount Merrion Avenue is completed. (Courtesy of the National Archives, Pembroke Estate)

Fitzgibbon, better known as Lord Clare. Thereafter, the 1800 Act of Union decreased the importance of Dublin and shifted all power to London. In fact, Richard's will of 1815 left Mount Merrion House and demesne to the use of his agent, Richard Verschoyle of Merrion Square, and Barbara, his wife, for their lives, and their descendants.

The Fitzwilliams, and later the Pembrokes, were absentee landlords and employed estate agents to run their affairs. These agents sometimes occupied Mount Merrion House, especially during the first half of the nineteenth century, but in later years the estate office was alongside No.1 Wilton Place, near Baggot Street Bridge, at the core of the main income-producing properties (the Pembroke Township). The most well-known agents were Bryan Fagan, and then his wife Elizabeth, in the middle of the eighteenth century, then their daughter Barbara (later married to Richard Verschoyle, who died in 1827 in Mount Merrion House), followed by Cornelius Sullivan, John Vernon, and finally his son Fane Vernon. Fane was a barrister and Justice of the Peace, and his involvement ended around 1923.

Around 1970, the office moved from Wilton Place to No.14 Fitzwilliam Place. No.1 Wilton Place is now an ESB crèche; the adjoining estate office (built in the late 1860s) was demolished to make way for an office block, until recently occupied by NIB Bank and now by a new office block known as No.7/8 Wilton Terrace.

The accounts for 1766 show that Elizabeth Fagan was paid a salary of £100 for collecting the rents of the estate, while her assistant, John Cantwell, received £40, which was a lot of money in those times. All the workmen in Mount Merrion *shared* an average weekly wage bill of £1 10s.

Sale of Estate

On 1 April 1916, James Adam & Sons, auctioneers, were commissioned to value the property for the purpose of selling it, and their report makes very

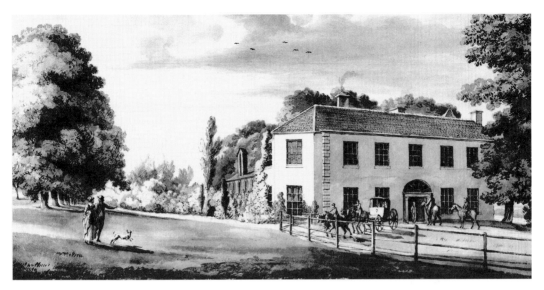

William Ashford painting (1805) showing the south face of Mount Merrion House.
(© Fitzwilliam Museum, Cambridge)

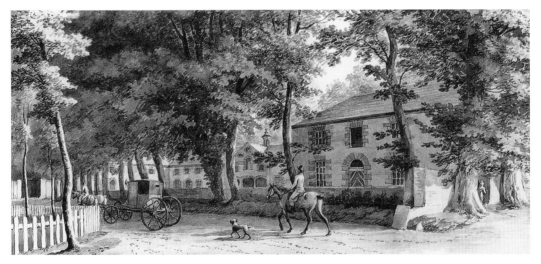

William Ashford painting (1805) showing the Mount Merrion House stables. The building on the
right was only demolished in the 1970s, and the present Scout Hall built on the site.
(© Fitzwilliam Museum, Cambridge)

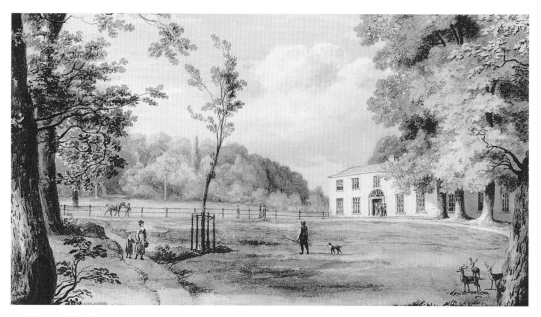

William Ashford painting (1805) showing Mount Merrion House from main East Avenue.
(© Fitzwilliam Museum, Cambridge)

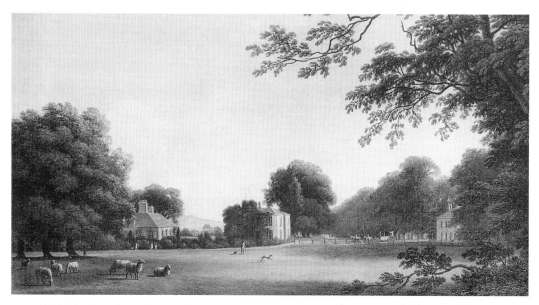

William Ashford painting (1805) looking east. The stables are on the extreme right, Mount
Merrion House (The Lodge) in the centre (half-hidden by trees), and the servants' wing on the left.
(© Fitzwilliam Museum, Cambridge)

interesting reading. The Mansion House consisted of two distinct buildings, joined together by a two-storey structure, built upon arches, spanning an open courtyard, containing the following rooms:

Front Wing

Nine-foot wide hall, drawing room, dining room, study, all on ground floor.
Four bedrooms, a dressing room and bathroom on the first floor.

Rear Wing

Large sitting room, housekeeper's room (formally a billiard room), kitchen, scullery, larder, dairy, all on ground floor.
Four family bedrooms on first floor.
Four servants' bedrooms in attic.

Link

Butler's pantry and servant's bedroom on lower floor.
Two servants' bedrooms and bathroom on upper floor.

The stables contained coach houses, stables, laundry, and men's dwellings.

The farm buildings included a stable, cart shed, shed, cow shed, steward's cow house, detached carpenter's building, bothy.

There were three gate lodges, a steward's house near the garden, and two workmen's dwellings on Callary Road (now called Lower Kilmacud Road).

The buildings in the walled garden included a melon pit of brick, timber and glass, a 100ft-long peach house, a 100ft-long vinery, and a cucumber pit.

The entire estate was surrounded by a stone wall, 10ft high.

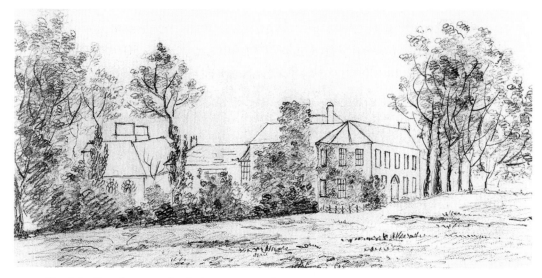

Sketch by Hamilton Verschoyle (c. 1824-7). This gives a more accurate view of Mount Merrion House, with the servants' wing on the left, the link, the main house, and the 1760s extension on the right (this extension is now part of the Community Centre).

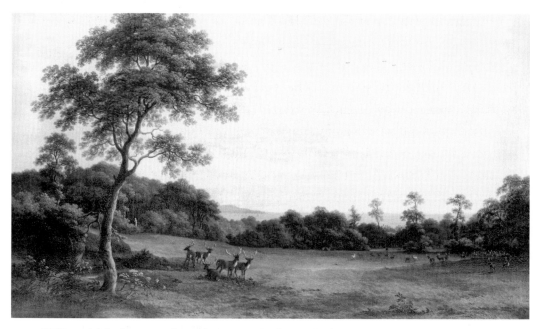

William Ashford painting (1805) showing the deerpark of Mount Merrion House, with Howth in the distance. (© Fitzwilliam Museum, Cambridge)

By deed dated 13 December 1918, the Earl of Pembroke sold the house and estate of 298 acres to Thomas Joseph O'Neill for £28,500. He in turn sold it on to Thomas Wilson for £36,000, by deed dated 3 February 1919. By 1928, Wilson had sold the property to Mount Merrion Estates Ltd for £15,000 plus charges of £21,000 (presumably a mortgage). By 1933, Irish Homes Ltd had acquired the estate, and so began the era of the 'Kenny Built' Garden City, so much beloved of auctioneers thereafter.

Deerpark

The biggest attraction in Mount Merrion is the wonderful County Council park, extending to about thirty-four acres, and commanding a fantastic view of Dublin City and Bay from its vantage point of 265ft above sea level. The park owes its origin to two neighbouring demesnes: those of Fitzwilliam/Pembroke, and Mount Anville Convent, the former being represented by the wood and land as far as the Mount Anville Road entrance, and the latter comprising the open area alongside Mount Anville Park housing estate. In fact, the diagonal path which connects the Mount Anville Road gate with the Redesdale Road gate represents the old boundary wall between the two estates.

The wood in the Fitzwilliam section of the park corresponds exactly with the wood shown on all the estate maps back to at least the early eighteenth century. Cullen's map of 1722 refers to Woodhill, and Barker's map of 1762 specifically shows the wood, with a gazebo near the west end and thirty-two paths radiating from there. A painting by William Ashford in 1806 shows the same arrangement. By 1831, the wood is shown as more informal, with only five radiating paths. The large area between the mansion house and the wood is marked as Woodlawn, and this is where the present St Thérèse church and Scoil San Treasa Primary School were built in the 1950 and '60s.

By the late 1950s, Dublin County Council decided to acquire the land by compulsory purchase and an arbitrator was appointed to assess

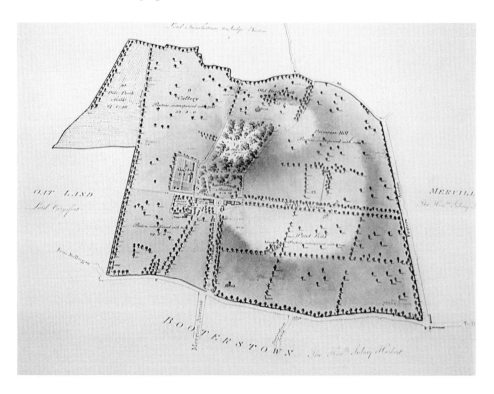

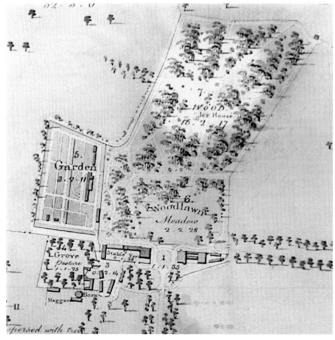

Mount Merrion demesne, 1831. (Courtesy of the National Archives, Pembroke Estate, 2011/2/5)

Close-up of top photo: the house complex is on the right, the stables on the left, and the farmyard below.

Valuation Office map (1860s and '70s) showing various estates and parcels of land around Mount Merrion.

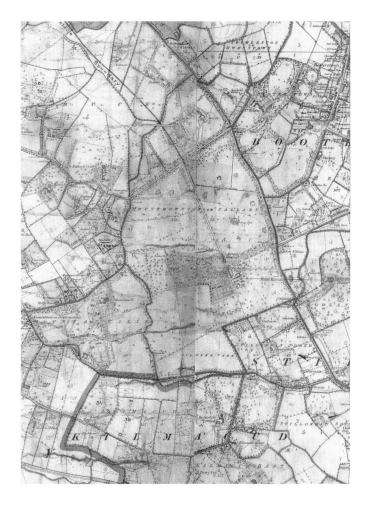

compensation, holding public hearings in 1961 and 1962. Hence, twenty-four acres was acquired from Wilson and Maher via this process, for £6,250, and similarly with a one-acre plot owned by the Smurfit family. By 1971, the council could effectively declare the public park open.

The late 1970s saw Mount Anville convent selling off the farm portion of their ninety-acre estate, resulting in the construction of houses in Mount Anville Wood and Mount Anville Park. A condition of the planning permission stipulated that seven acres of open space be allocated for the new residents. Quite sensibly, this was positioned alongside the recently

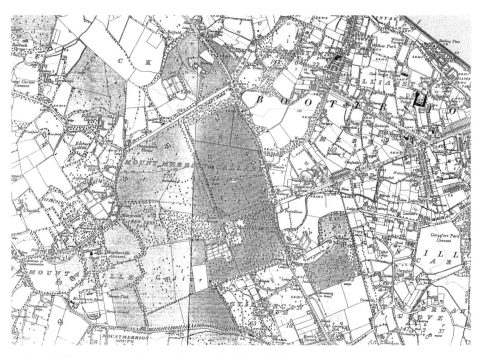

Ordnance Survey map of Mount Merrion locality, 1907.

opened Deerpark, and by demolishing the separating wall, a much larger public park emerged.

Only in 1998 was the final piece of the park acquired by the council, for £15,000, and this is now the site of the children's playground, which opened in 2006. This small plot belonged to David Whitren, who originally had planned to build his Stella ballroom here, but opted instead for the site across the road (the present Kiely's pub).

In the nineteenth century, it was fashionable for all the 'big houses' to have a deerpark, usually for the sport of stag hunting, but also as 'window dressing' and sometimes for a supply of tasty meat. Sometimes deer were stored on smaller estates and then transported and released for a big hunt, such as the Ward Union Hunt in north County Dublin. The 1831 estate map shows a sunk fence between the old deerpark (the field to the west of the wood) and the larger northern portion of the estate; this was a step

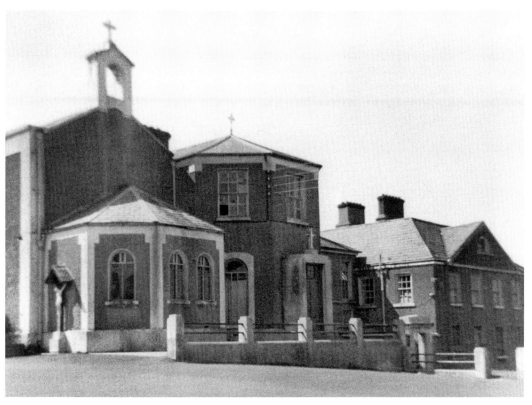

East side of Mount Merrion House in the 1970s: the 1930s chapel is on the left and the 1930s National School is on the right. (Courtesy of Kevin Harrington)

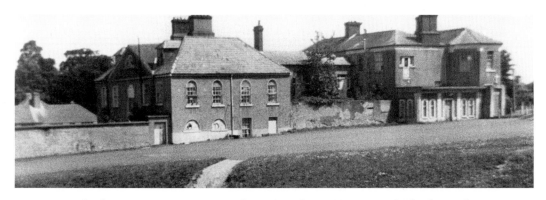

West side of Mount Merrion House in the 1970s: the 1930s National School is on the left and the 1930s chapel is on the extreme right. This chapel was the 1760s extension to the main house. The house was demolished by the parish in 1976, leaving only the 1760s extension as a Community Centre. (Courtesy of Kevin Harrington)

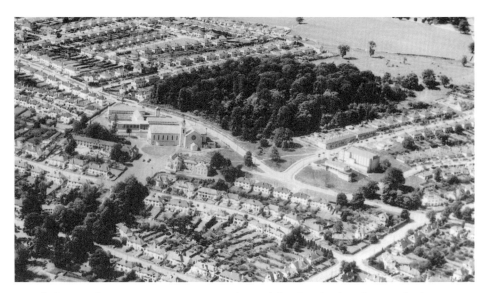

Aerial photo with Mount Merrion House in front of the church of St Thérèse, the former stables in front of Scoil San Treasa, and Mount Anville school to rear right, 1960s. (Courtesy of Aerofilms)

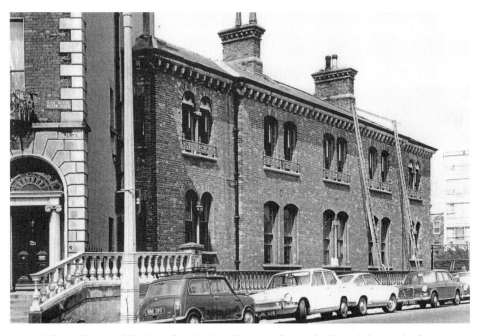

No.1 Wilton Place, Dublin 2, in the 1970s. This was the head office of the Pembroke estate, who succeeded the Fitzwilliam family. (Courtesy of Irish Architectural Archives)

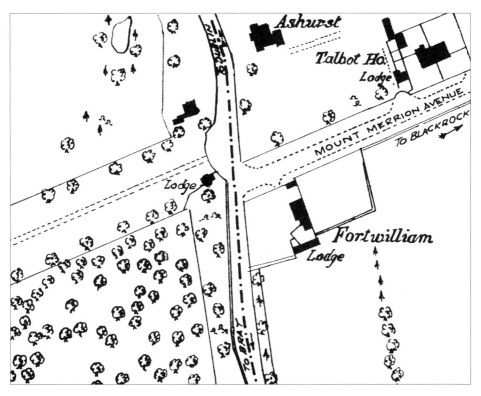

Map of the main entrance to demesne, 1930s. (Courtesy of ESB)

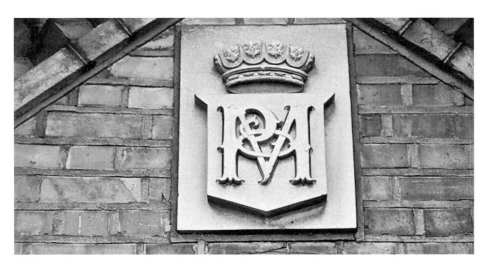

Coat of arms of the Pembroke and Montgomery family, still on No. 1 Deerpark Road, a former demesne lodge.

in the land in order to contain the deer. This 'ha-ha' enabled vehicles and people to pass in front of the main house, to and from the stables and the farmyard, without being seen by the gentry inside or spoiling the vista. Nowadays, part of the sunk fence can be seen in the lane behind the shops on Deerpark Road, comprising a low section of stone retaining wall. When Mount Merrion demesne was sold in 1918 to developers, three of the fallow deer were shipped live in crates to the Pembroke main estate in England (and arrived safely!). It seems that the remaining twenty-six deer were left to run wild on the estate, although other big houses or hunts may have taken them away.

Other remnants of the old demesne, which were enjoyed by local children for decades, were the Ice House, near the east side of the wood, and the cold-water storage cistern on the west side of the wood. The former was a stone or brick-lined underground room used to store perishable food in the days before the refrigerator, and the latter would have supplied the house and farmyard with water – the elevated location of the tank relative to the house would have provided good pressure. These are now long gone.

2

RELIGION

Church of St Thérèse

In 1787, Booterstown, Blackrock, Stillorgan and Dundrum were made into one parish, following a separation from Donnybrook (which also included Ballsbridge, Ringsend and Irishtown). There was only one chapel to serve this large area, located in Booterstown Avenue, which was built around 1697. By 1812, a new chapel was built on the same site, at the sole expense of Lord Fitzwilliam (although by now the family were Protestants), largely at the request of the family agent Mrs Barbara Verschoyle, who was a Catholic. A chapel of ease was built in Dundrum in 1813, to make it easier for parishioners in that part of the parish to attend Mass. Another chapel of ease was provided in 1867 in Kilmacud, to serve the villages of Stillorgan and Kilmacud, and named after Sts Laurence and Cuthbert. This chapel was in fact a converted section of the 1840s National School, because pupil numbers had fallen after the Ladies of Mount Anville opened a National School, further up the road towards Goatstown, in 1866. A new curate's house was built alongside the Kilmacud chapel of ease. Dundrum church was rebuilt in 1879, at which stage Dundrum and Kilmacud split from Booterstown to become a separate parish.

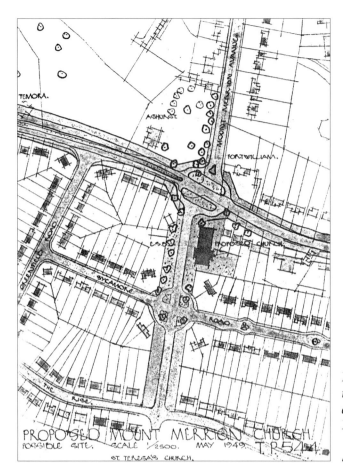

Proposal to build the new church of St Thérèse alongside the main Dublin Road (now N11), where 'Woodville' now stands in Sycamore Crescent, 1949.

The Fitzwilliam residence, Mount Merrion House, was sold in 1918, but house building only took off in 1933, when Irish Homes Ltd started developing their 'garden city', under John Kenny Builders. In 1935, Irish Homes Ltd sold the old mansion and some land to Archbishop Byrne for £2,000, on a 900-year lease, at a ground rent of 1s a year. This was a bargain price, since Adam's Auctioneers had valued the house alone in 1916 at £3,600. Nowadays, all Church property is held by the St Laurence O'Toole Diocesan Trust. Fr Farrington, the parish priest of Dundrum and Kilmacud, was entrusted with the task of providing a chapel of ease in Mount Merrion. Using the south block of the old house (1760s), he

extended and converted the ground floor into a homely chapel and used the first floor as the curate's residence. The rest of the old house (north block) was converted into a National School in 1939. In 1948, the chapel of ease separated from Dundrum parish and was incorporated into the new parish of Mount Merrion and Kilmacud. A site at the corner of the Stillorgan Road and Sycamore Crescent was initially chosen for a new church, but eventually the hill site to the west of the old mansion was chosen. 'Woodville' was later built by Sharpe on the Sycamore site.

In 1953, the foundation stone for the new church was laid; it was completed by February 1956 and dedicated to St Thérèse of the Infant Jesus. Architect John Robinson (now the practice of Robinson, Keefe & Devane) designed the church, and it was built by John Philip du Moulin Ltd. The construction meant that a giant redwood tree was cut down, although one beauty remains, near the south side of the church.

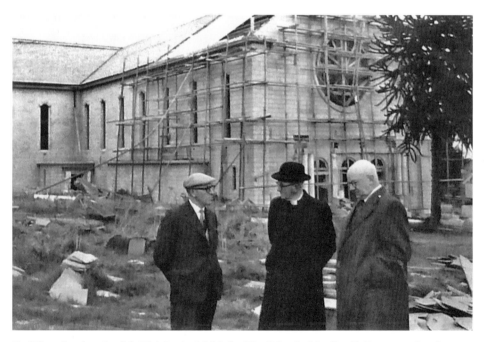

Building the church of St Thérèse in 1955: builder John du Moulin, Fr Deery, and architect John Robinson. (Courtesy of Biotrin)

John du Moulin Senior. (Courtesy of Biotrin)

The main walls are of reinforced concrete, faced with chiselled ashlar granite from County Dublin, and Ballinasloe limestone dressings around the windows and to the portico at the rear, all drylined with plasterboard on timber battens internally. The double-pitched roof comprises steel trusses supporting timber rafters and timber boarding, and covered with green Westmoreland slates. A tower/belfry is attached to the north-east corner, complete with copper cupola and rope-operated bell. The 25cwt (hundredweight) bronze bell was cast in 1954 in the Matthew O'Byrne Bell Foundry (also called the Fountain Head Bell Foundry) at No. 42 James's Street. The Latin inscriptions on the bell's exterior refer to Archbishop McQuaid of Dublin and Fr Deery, the parish priest. The bell was abandoned in 1984 in favour of a recording, broadcast via amplifiers mounted in the cupola, but nothing beats the mature tone of a real bell.

The confession boxes project externally, so as to provide a flush wall inside the church. The ceiling of the church is a segmental shape, and plastered

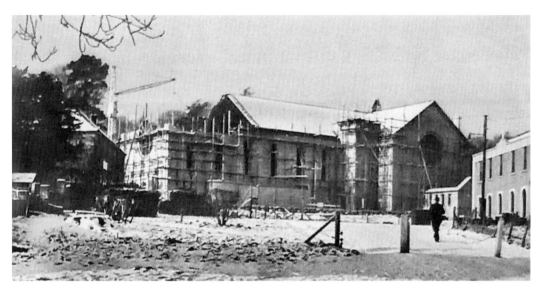

Building the church of St Thérèse in the 1950s. Note part of the former stables on the left, which became the Barn youth club, and is now the site of the Scout Hall. (Courtesy of Biotrin)

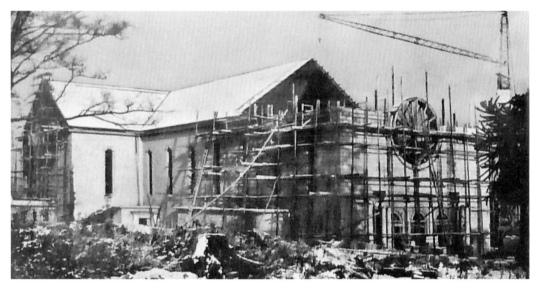

Building the church of St Thérèse in the 1950s. Timber scaffolding was used. (Courtesy of Biotrin)

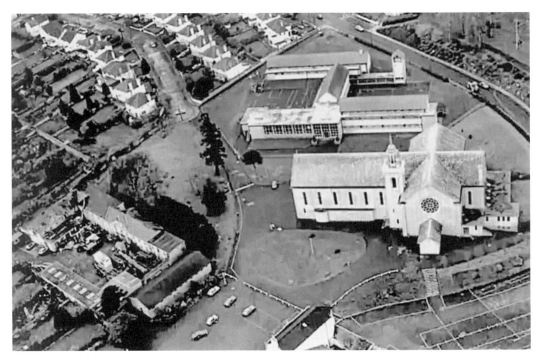

Church of St Thérèse and Scoil San Treasa. Note the former stables bottom left, used as John du Moulin's builder's yard (now Biotrin).

to give a coffered appearance, with lights sunk into the coffers. The ceiling rises in a slight dome shape over the crossing of the nave and transepts, and the words 'Matthew, Mark, Luke and John' are a feature of the corners. The famous firm of M. Creedon Ltd was responsible for all the plasterwork.

A novel feature for the 1950s was the heated concrete floor, with hot water flowing through embedded steel pipes, all powered by an oil-fired boiler. The concrete floor was then covered with asphalt and decorative rubber in the circulation areas, and hardwood woodblock flooring in the seating areas. John du Moulin was the first church builder in Ireland to use a Liebherr tower crane.

The teak seating was made by Gillian & Co. of Kilmainham. A rear balcony was provided, but no organ. There are 17ft diameter limestone rose windows in the rear and the two transepts, while the nave windows

feature leadwork and lightly coloured glass, in contrast to the dark-green glass used for the cross in each window.

Artist Sean Keating was responsible for the painting of St Thérèse in a side altar off the west transept, consisting of two panels of hardboard. Sean is better known for his paintings of the men from the Aran Islands, and the construction of the first ESB hydropower station at Ardnacrusha, County Limerick. Another artist, George Collie, painted the Stations of the Cross.

The basic building cost £139,000, which was partly donated by people from all over Ireland who were asked to sponsor a stone. Another £60,000 was spent on seats, altars, statues, etc., bringing the total to around £200,000. Mortgages were unheard of in those days, so the parishioners spent many years fundraising by means of garden fêtes, concerts and the

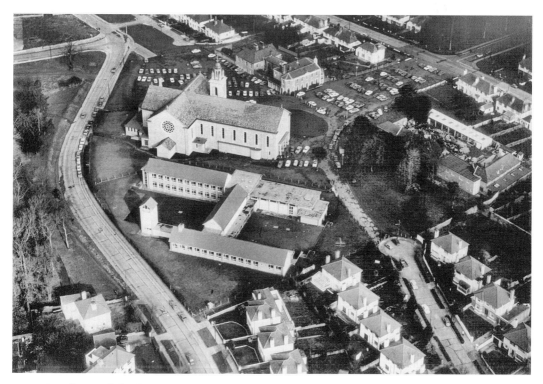

Aerial view of the church of St Thérèse and Scoil San Treasa in the 1970s. Note the old Mount Merrion House in centre rear and former stables to right.

Visitors to the car park of the church of St Thérèse, March 2001. Note the condemned Community Centre, which was the 1760s extension to the old Mount Merrion House.

like. The annual Mount Merrion Horse Show in St Helen's (CBS) was great fun, and raised some of the funding.

In the early 1940s, Fr Farrington had plans to convert part of the old stables into a Céilí/Parish Hall. This imposing building was at the north end of the stables, facing the main mansion house (the rest of the stables were of a different design and owned by builder John du Moulin). The Céilí Hall was intended to be on the ground floor of the building, but instead a ballroom was provided on the first floor. The Espoir Youth Club was started by teenagers in January 1957 in a barn attached to Cosgrave's farm on Roebuck Road. When the parish priest heard about the youth club, he immediately offered the teenagers space in the Parish Hall, but the name 'The Barn' stuck. Their first dance here was held in August 1957.

Teenagers from miles around would flock to this venue for dances. The Barn was condemned in 1961 and the Espoir Club moved across into the former chapel of ease, continuing to call it the Barn. The old and new Barns were the venues for many concerts, dances and clubs over the years, with the proceeds going to the church building fund. There was even a musical society and a canoeing club.

The old ballroom beside the stables was abandoned, and caught fire in 1968, after which it was demolished. In 1976, the Scouts built their den on the site, and this building is still being used by the Boy Scouts and the

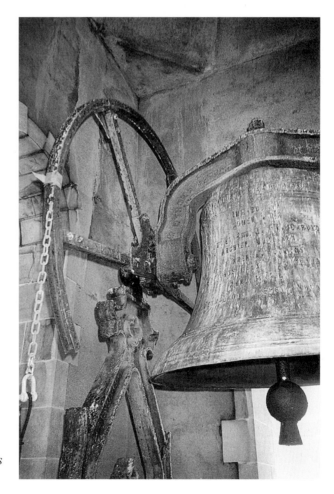

One-and-a-quarter-ton bell in the tower of the church of St Thérèse, cast in 1954 by Matthew O'Byrne Bell Foundry, Dublin. The Latin inscription refers to Archbishop McQuaid and Fr Deery. The bell is now abandoned and a recording is played instead.

Jubilee of the church of St Thérèse, 2006.

Girl Guides. However, part of the old rear wall is still standing, comprising rubble granite and cut limestone dressings.

In 1979, the new Barn was abandoned in favour of a newly built Community Centre, where teenage discos were held.

In 1989, the north car park was jointly developed with the county council, reflecting the increased use of motor vehicles to get to church.

By 2003, the historic old section of the Community Centre (part of the Fitzwilliam mansion) was substantially rebuilt (except for the four main walls and a brick-vaulted wine cellar) and a new block built to link the

1979 community hall to the old section. Surprisingly, none of the present windows face towards Dublin Bay, thereby deprieving users of wonderful views. Nowadays, various rooms in the Community Centre are hired out to myriad clubs from all over Dublin and the new basement is hired out as a crèche. On Sundays, the centre is closed.

To mark the silver jubilee of the church in 1981, the altar was replaced and turned around, to reflect the new Catholic doctrine. The golden jubilee of the church in 2006 was celebrated by expending nearly €2 million on redecorating, refurbishing, and forming a large baptism and standing area at the rear. The project involved the total removal of the concrete floor and installation of new underfloor heating. During this seven-month project, Mass was held in the Community Centre hall on weekdays and in the nearby Scoil San Treasa Hall on Sundays. In conjunction with the refurbishment, the parish priest was granted a coat of arms by the Chief Herald of Ireland, with the motto, '*In Corde Ecclesiae Amor*'.

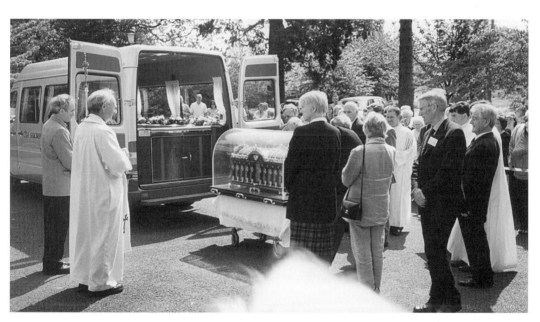

Relics of St Thérèse of Lisieux (France) visit the church of St Thérèse, as part of a countrywide tour, 2001.

Sunday Mass in the hall of Scoil San Treasa, during the refurbishment of the parish church, 2006.

Catholic Communications Centre

With the arrival of RTÉ, the Irish Catholic Church became aware of the power of broadcasting. The Dublin Institute of Catholic Sociology, No.14 Gardiner Place, whose patron was Archbishop McQuaid, was sending priests to ABC Television in Manchester, England, for a special religious-broadcasting training course. Fr Joseph Dunn, a curate in Rialto, went on the one-week course in June 1959. In September 1959, Fr Joseph Dunn and Fr Des Forristal were sent to the Academy of Broadcasting Arts in New York to do a three-month course in broadcasting. By 1961, Joseph Dunn was in the UCD chaplaincy (No.84 St Stephen's Green), and he was sent to Antwerp in Belgium with Fr Des Forristal, Fr Peter Lemass and Fr

Weekday Mass in the Community Hall during the refurbishment of the parish church, 2006.

Old floor in the church of St Thérèse being cut up and removed, 2006.

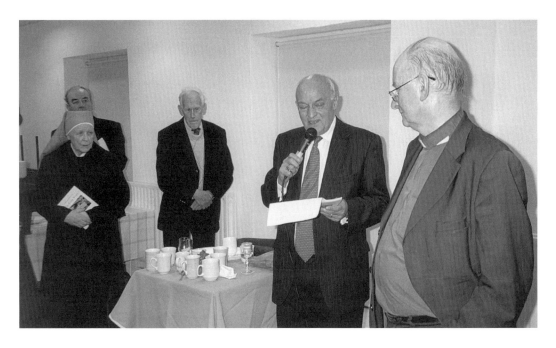

Launch of Don Cockburn's booklet on the history of Mount Merrion, in the Community Centre, 2007. Bishop Walsh of Limerick Diocese is on the right (reared in Sycamore Road).

The north block of the former Mount Merrion House stables in 1957. The Espoir Youth Club used the first floor, calling it 'The Barn'. (Courtesy of the Irish Independent*)*

Ground floor of north wing of the former stables of Mount Merrion House. (Courtesy of Irish Architectural Archives)

First floor, north wing of the former stables of Mount Merrion House, which was used by Espoir Youth Club. (Courtesy of Irish Architectural Archives)

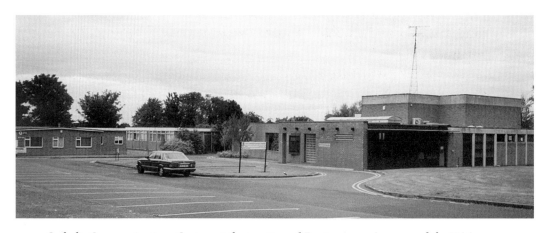

*Catholic Communications Centre, at the junction of Booterstown Avenue and the N11,
2006. Now the site of Thornwood apartments.*

Donal Flavin to do a course in film-making. Des Forristal and Joseph Dunn
immediately began making short documentary films with a religious
flavour, and persuaded the recently opened RTÉ to screen their first edition
of *Radharc* on 12 January 1962.

On 10 August 1963, Dunn was appointed chaplain in the Dominican
convent, No.123 Mount Merrion Avenue, to facilitate his work in making
the *Radharc* films for RTÉ. Initially, RTÉ paid Dunn £125 per episode and
assisted in processing the film, etc. By 1964, they had increased the fee to
£250. In 1965, McQuaid granted Dunn permission to make films in Africa.

The Church now saw the need for a purpose-built Catholic
Communications Centre, and so the Catholic Truth Society of Ireland
(founded in 1899) bought three acres of land for £11,100 from the
Christian Brothers estate of St Helen's, at the corner of the Stillorgan Road
and Booterstown Avenue. The new centre opened in 1967, having been
built for £54,000 (including equipment), and provided eight-week courses
in religious broadcasting. Fr Joseph Dunn was its first director, but he
continued to produce *Radharc* films for RTÉ as a separate business.

In 1969, the Catholic Communications Centre amalgamated with the
Catholic Truth Society to form the Catholic Communications Institute of

Ireland, with the publishing arm in Veritas House, No.7-8, Lower Abbey Street, from 1970.

In 1970, the CCII bought nearby Pranstown House, on one-and-a-half acres (on the other side of Booterstown Avenue, beside South Hill Park), for £24,250. Previously called Temora, this house comprised four reception rooms, five bedrooms, two bathrooms, servants' quarters, a double garage, and even a heated greenhouse. Dunn and his *Radharc* crew moved into Pranstown House, but by 1974, Dublin County Council compulsorily acquired part of the property for £150,000 for road-widening purposes, and later demolished the old house. Irish Nationwide Building Society bought the rest of the land from the CCII in 1977 and constructed a large block of apartments there in 2008. Named Booterstown Wood, the apartments were not put on the market until October 2010 – and then at half price.

The first director of the Communications Centre was Fr Joseph Dunn, followed by Fr Peter Lemass, and then Bunny Carr. Besides offering broadcasting courses to priests and making *Radharc* films, the centre also made promotional films for Trócaire and Gorta (both Church-sponsored

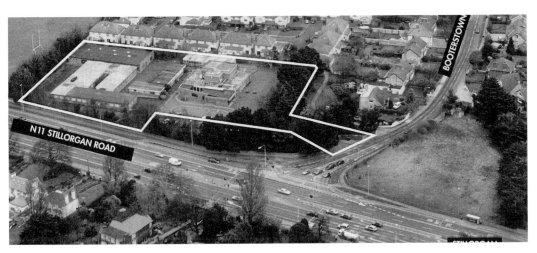

An aerial view of the Catholic Communications Centre, at the junction of Booterstown Avenue and the N11, 2006. Now the site of Thornwood apartments.

Pranstown House at the top of Booterstown Avenue in the 1970s. Now occupied by Booterstown Wood apartments. (Courtesy of Dún Laoghaire–Rathdown County Council)

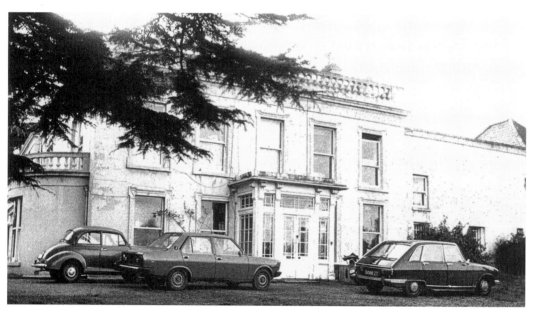

Pranstown House (previously 'Temora') in the early 1970s, when in use by the Radharc film crew as part of the Catholic Communications Centre. (Courtesy of ESRAS)

overseas aid agencies) and for various missionary orders. In fact, Trócaire was based in the centre in Booterstown. The accounts for the period 1969-71, showed that RTÉ paid the centre £11,288 and other organisations paid £8,845.

Peter Lemass died in 1988 and Joseph Dunn in 1996, at which stage *Radharc* ended, after making more than 400 films, both in Ireland and around the world. However, the films can still be purchased from Esras, at No.43 Mount Merrion Avenue, which manages the collection on behalf of the Irish Film Archive and Radharc Trust.

Bunny Carr is probably the most famous lay person associated with running the centre. He went on to start his own company, Carr Communications, in 1973, which specialised in grooming politicians and business people for television appearances, especially *The Late Late Show*. After Radharc ceased production in 1996, Carr Communications moved into the refurbished Communications Centre, and stayed until 2004, when there was a management buyout and the company moved to Sandyford Industrial Estate. Most people probably remember Bunny Carr as a broadcaster on RTÉ, where he fronted the afternoon show *Going Strong* from 1975 to 1983, and *Quicksilver* (a quiz show with low prize money) from 1980.

3

EDUCATION

Mount Anville Boarding School

Mount Anville, probably built around 1801, adjoined the west side of Mount Merrion demesne, the property of the Fitzwilliam family. It was originally part of the land of Lord Trimleston and in the townland of Roebuck.

Lewis, writing in 1837, states that Mount Anville was occupied by the Honourable Charles Burton, Second Justice of the Court of Queen's Bench, and is remarkable for its richly cultivated gardens and extensive conservatories. From 1839 to 1851, Elizabeth West occupied the property, which included a pleasure ground, ponds, fountains, various lodges, and even a Mass House at the rear (sized 33ft x 15½ft x 12½ft high). At that stage, a 10ft-high stone wall surrounded the estate.

From 1851 to 1865, William Dargan, the famous railway contractor, was the owner, and he called the property 'The Tower'. Dargan was born in 1799 to a small farmer in County Carlow, and trained as a surveyor in England, working for the famous iron bridge builder Thomas Telford. Returning to Ireland, he built Ireland's first passenger railway in 1834, from Dublin to Kingstown (Dún Laoghaire), and went on to build many

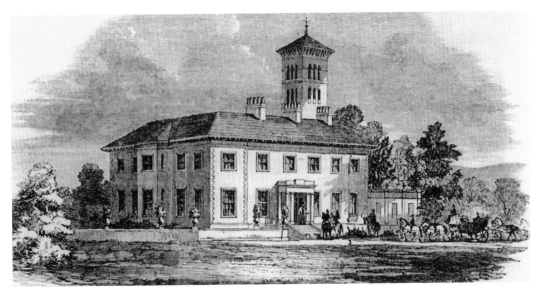

Visit of Queen Victoria to Mount Anville to offer railway contractor William Dargan a knighthood, 31 August 1853. He politely declined.

more railways and canals throughout Ireland. He is credited with creating the Dargan Channel in Belfast Port (also called Victoria Channel), and using the dredged material to form Queen's Island, which later became the shipyards of Harland & Wolff. He became very wealthy, and was able to sponsor the Dublin Industrial Exhibition on Leinster Lawn in 1853, to the tune of £100,000 (losing £20,000 in the process).

However, his endeavours in the 1850s to grow flax in County Cork, in addition to building the associated linen mills (including one in Chapelizod, County Dublin), were not successful. In 1865 his financial difficulties forced him to sell his house and farm in Mount Anville. The Valuation Office records that in 1864 the ninety-two acres were leased from Henry Kemmis, and that the property was 'much improved by Mr Dargan – dwelling enlarged, and new roofs and Tower. A first class mansion and beautiful situation.' The Valuation Office also noted that Dargan was selling the property for £35,000 (but eventually only obtained £10,000). Following a horse-riding accident, Dargan died in

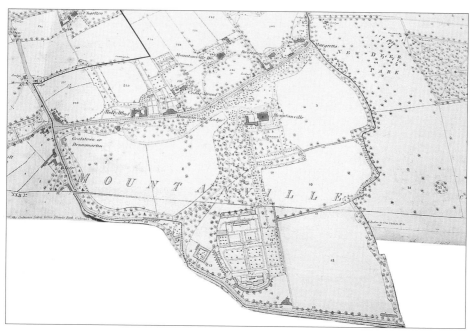

A map of Mount Anville demesne, 1866. Note the walled garden at the bottom and the farmyard to its left. (Courtesy of the National Archives)

1867 at his townhouse, No. 2 Fitzwilliam Square, leaving his widow Jane (*née* Haslam?), but no children. In 1864, the new National Gallery erected a statue on their front lawn in his honour, as he was instrumental in founding the gallery, shortly after the Great Exhibition on the adjacent Leinster Lawn.

In 2005, Dargan was again honoured when the newly opened cable-stayed Luas railway bridge at Dundrum was named after him. He is still remembered in Bray for bringing the railway line, building the promenade, and various other ventures. His flax-spinning mill in Chapelizod was built in 1856 near the Salmon Leap; it was converted into the Phoenix Park Whiskey Distillery in 1878, lasting until 1921.

The Ladies of the Sacred Heart struck a tough deal when they secured Mount Anville in 1865 for the bargain price of £10,000, no doubt assisted by Archbishop Paul Cullen. The deeds list the purchasers as Alexander

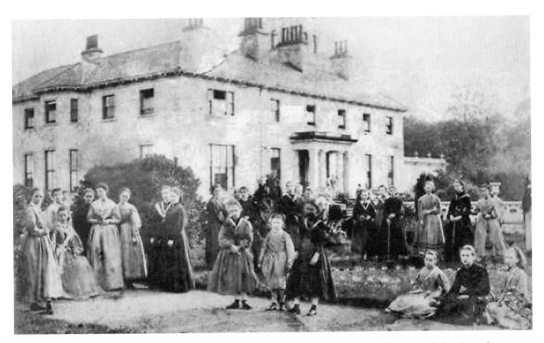

First group of boarders arrive at Mount Anville, 1865. (Courtesy of Sisters of the Sacred Heart)

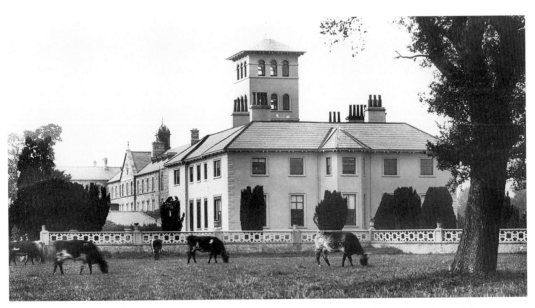

Mount Anville, side and rear, pre-1888. Note that chapel is not yet built. (Courtesy of the National Library)

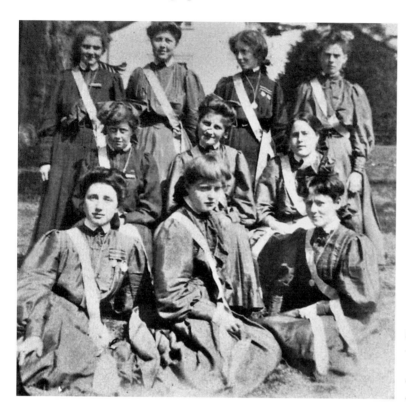

'Blue Ribbon' girls (prefects) in Mount Anville, 1908. (Courtesy of Sisters of the Sacred Heart)

Bayle of College Green, Anna Butler, Susan Moltau, Anne Murphy, Susan West, Teresa Harrington, Frances Cravin – all of Glasnevin – and Anne Murphy of Roscrea. The lease was for the remainder of 300 years from 1801, with Thomas Kemmis listed as the lessor. The property came fully stocked with herds of cows and sheep, pigs and hens. Where did the nuns get such a large sum of money? All the top positions in the Order were held by ladies who came from wealthy Catholic families and usually a large dowry of money or property was given to the convent when a daughter took vows, similar to the rural tradition when a dowry was given by a girl's parents when she married. In 1865, the dowry of Sr Marcella Hynes paid outright for the Mount Anville property.

The Order of the Sacred Heart was founded in France in 1800 by Madeline Sophie Barat, and spread to Roscrea in County Tipperary in

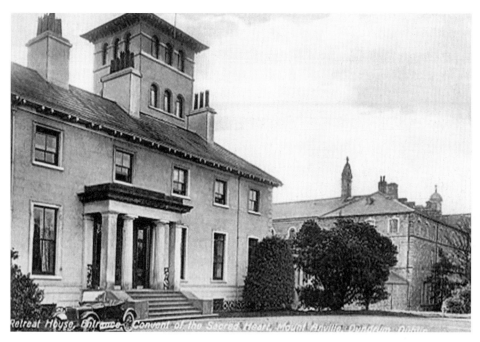

Early twentieth-century view of Mount Anville, then known as the Retreat House.

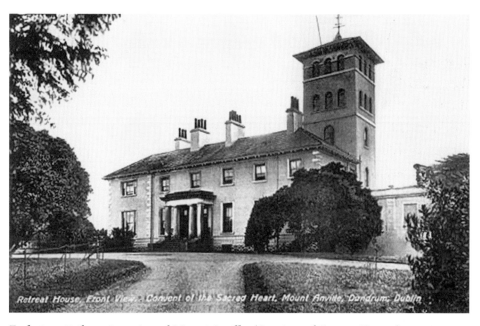

Early twentieth-century view of Mount Anville. (Courtesy of Seamus Kearns)

1842, Armagh in 1851, and Glasnevin in 1853. However, the north side of Dublin did not suit the ladies, so they sold that property to the Holy Faith nuns and moved to the spectacular setting of Mount Anville in 1865, bringing their thirty girl boarders with them.

Within three years, a new, rectangular, three-storey (plus attic) boarding school had been built, approximately 30m distant from the convent, utilising granite quarried on the farm (the quarry was under the present hockey pitches), at a cost of £10,000. Nowadays this building is recognisable by the clock and gable section in the centre of the south elevation, and the copper-clad dormer windows. The dormer windows at the front are tiny, maybe for reasons of privacy, whereas the rear ones are larger, and the high attic space was subdivided as rooms for novices. There are many chimneys, but only a few open fireplaces remain in random classrooms.

The famous architects Pugin & Ashlin designed the boarding school, and the equally celebrated Meade carried out the building work. A cloister or corridor linked the new boarding school to the convent building. Within the next few years, additional wings were added to the south-west, south-east, and north-west corners of the original boarding school, the north-west wing containing fourteen small piano practice rooms.

Other important dates thereafter include:

1869: The day boarding school was launched (the girls went home at night, but had all their meals in the school).

1889: The south-east wing of the boarding school was demolished and a chapel built, at the expense of the head office in Paris. It was open to the public. The chapel was built at a time when it was partly visible from the road, and so it had to be disguised to satisfy the Protestant authorities. Therefore, the chapel is entered at first-floor level, so that the overall height matches the adjoining boarding school, and there are various rooms underneath the chapel. Internally the chapel is plain, except for some nice stained-glass windows dedicated to different saints.

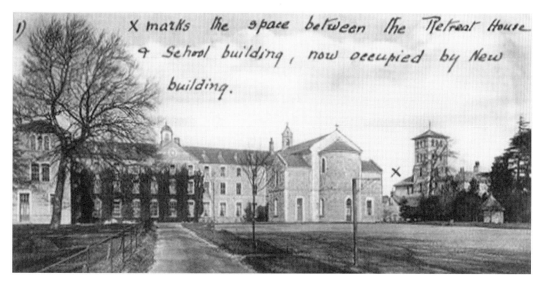

Rear of Mount Anville before 1922, when the gap at 'x' was filled in by a Novitiate.

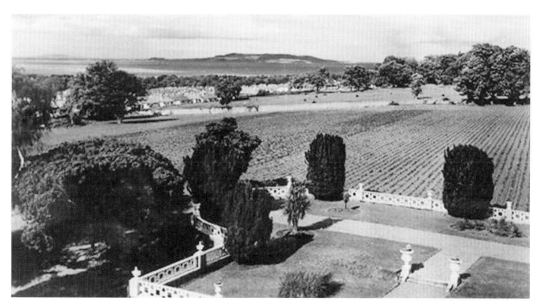

View from the rear of Mount Anville, looking over the deerpark of Mount Merrion House, with Howth in the far distance.

The St Michael window on the west side of the apse was provided for the centenary in 1900. George Ashlin designed this chapel, which was built at a cost of £5,800.

1922/3: The large, U-shaped, three-storey Novitiate was built between the convent and the boarding school, with plastered walls and battlemented parapets. A new semi-basement school hall, with two floors of classrooms above, was built at the same time, although the original ornate arch and surrounds to the stage opening were removed at a later date, reducing the grandeur of the stage. The entire structure was built without an architect or even drawings – the nuns simply told the builder, P.J. O'Grady, what they needed. The end result was that the north facade of the original boarding school was substantially hidden.

1939: The chapel was extended to the south by three bays and side aisles, supported by arches.

1944: A fourth storey was added to the south-west wing (also known as Music House or Angel's Wing) after removal of the twin-pitched slated roof.

1950s: The original cast-iron entrance gates and granite piers were moved from beside the present granite gate lodge to their present position, opposite the convent. However, the original gates are missing.

1950: A two-storey extension was built at the south-west corner of convent.

1954: A Montessori school was started in one room of the extension behind the convent.

1955: A secondary day school opened (Mater Admirabilis).

1966: The boarders and day girls were amalgamated.

1977: Thirty-four acres of land were sold to Gallagher Group for a housing scheme.

1981: The boarding school closed.

1980s: Cedar House Nursing Home opened (later extended).

1987: The ultra-modern sports hall was built.

2000: A new Montessori school opened near the south-west corner of convent.

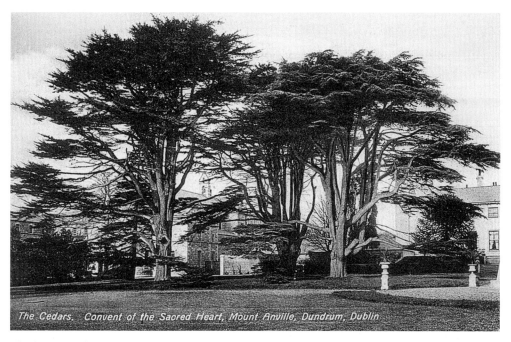

The famous cedar trees at the rear of Mount Anville. The modern nuns' nursing home is called Cedar House.

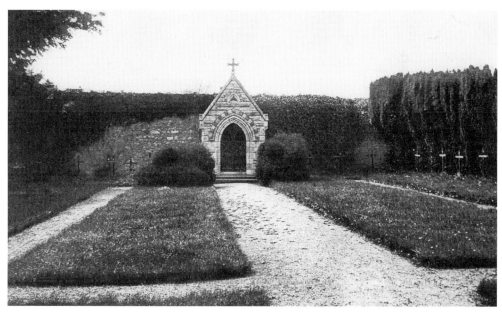

Nuns' cemetery, Mount Anville. Note the tiny oratory.

Mount Anville operated a large farm until the 1970s. The farmyard was at the south centre of the estate, and the main working farm had three large fields: Tower Field at the north (also called Calvary), Hidden Gem in the centre, and Botany Bay at the south (alongside the present primary school on Kilmacud Road Lower). The Hidden Gem was a small wooded area, with a quaint summer house in the centre.

The walled garden is still a most attractive feature of the estate. The 4m-high wall is brick-faced internally and rubble granite faced externally, and there is a centre east-to-west dividing wall, resulting in two large gardens. Both gardens still contain orchards and drills of vegetables. The long, wrought-iron framed glasshouse at the north end comprises a brick wall, against which the curved glass and frame rest. There are three compartments in the glass house, and a metal plate records the maker as W. & D. Bailey of 272, Holborn, London, probably in the early nineteenth century. Ogee-shaped brick arches are a feature of the door and window at both ends of the glass house, and this architectural feature is carried through into the remains of a partly demolished shell house, a residence outside the north-east corner of the walled garden. The nuns' cemetery adjoins the south-east corner of this garden.

The original convent doesn't appear to have changed much since Dargan's time, being six bays in width and in depth, and two storey over the basement. The front basement windows are barely visible from the forecourt, but the east basement windows and one rear basement window are not visible, since they are below a raised lawn which in turn is surrounded by a charming cast-iron ornate balustrade along the east side of the house, with especially decorative entrance gates. The external walls of the convent are smooth rendered, windows are vertical sliding timber sash pattern, and visible parts of the roof are pitched and slated, with a central copper flat area. The top floor of the tower contains a large cold-water storage tank, but the decorative ceiling mouldings are reminiscent of its function as a good-quality viewing room. Even the cast-iron staircase balustrade in the tower is noteworthy. Inside the house,

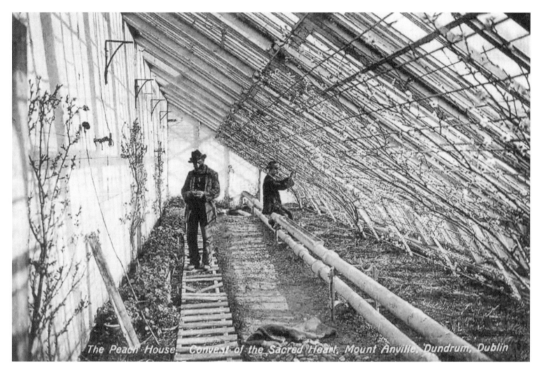

The peach glasshouse, in the walled garden at the rear of Mount Anville demesne, in the early twentieth century.

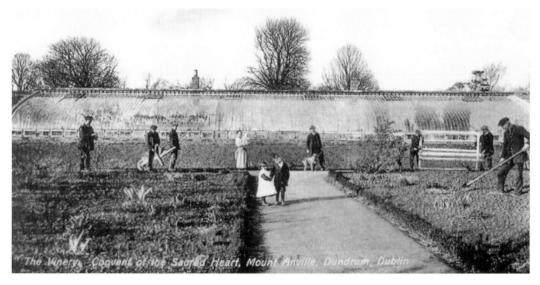

Small part of the walled garden, Mount Anville.

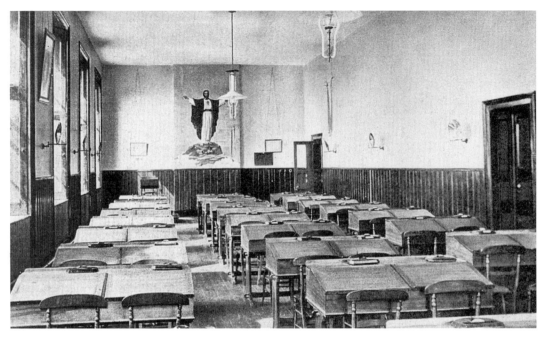

Study Hall, Mount Anville Boarding School, in the early twentieth century.

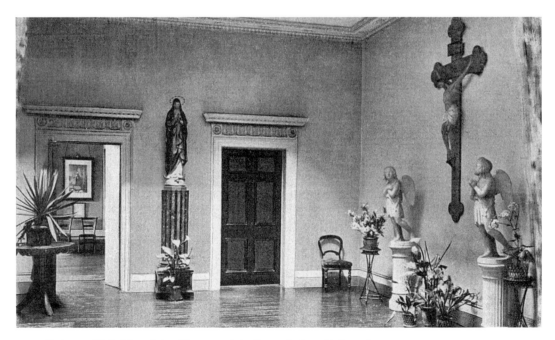

Entrance Hall, Mount Anville convent, in the early twentieth century.

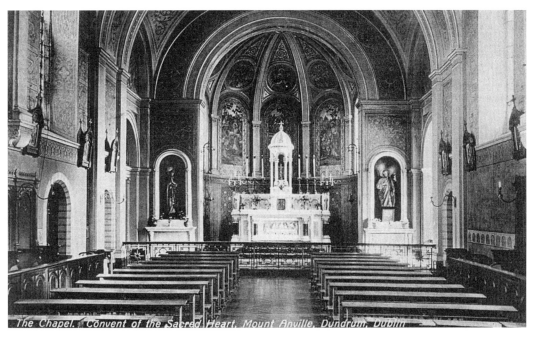

Chapel, Mount Anville, before the extension of the sanctuary.

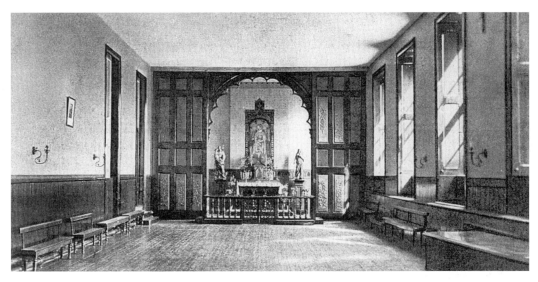

Recreation Room, Mount Anville, in the early twentieth century, with the doors of the Lady Chapel open.

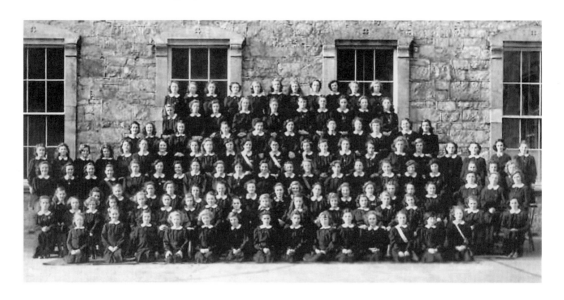

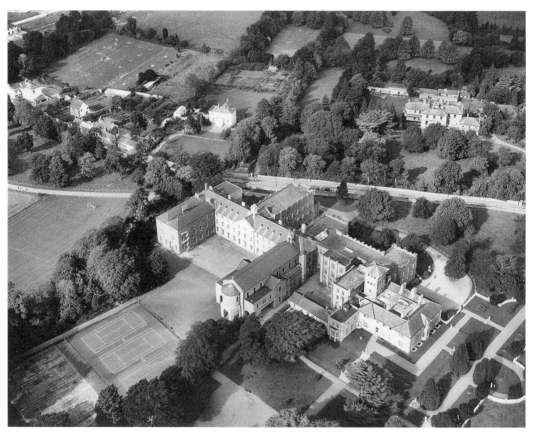

Opposite, from top

Mount Anville Boarding School girls, 1949. (Courtesy of Sisters of the Sacred Heart)

Aerial view of Mount Anville, 1950s. Note Knockrabo in rear right. (Courtesy of the National Library)

Right *View of the Giant Redwood* (Sequoia sempervirens) *planted by Queen Victoria on 17 May 1900 in front of Mount Anville Convent (2010).*

Below *'Bishop's Door' in the original 1868 Mount Anville Boarding School.*

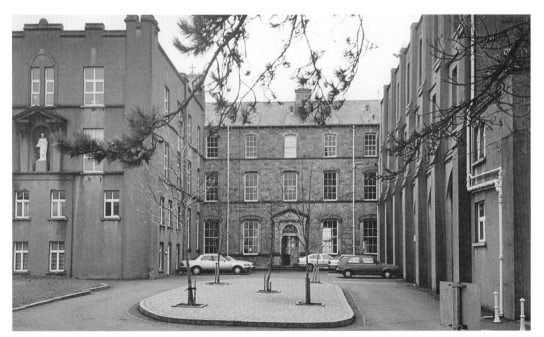

Beautiful wrought-iron gates to Sacred Heart Walk (leading to walled gardens and cemetery) in Mount Anville, made by Richard Turner of Hammersmith Works, Shelbourne Road, Ballsbridge. They also made the glasshouses in the Botanic Gardens, Dublin, and in Kew Gardens, London.

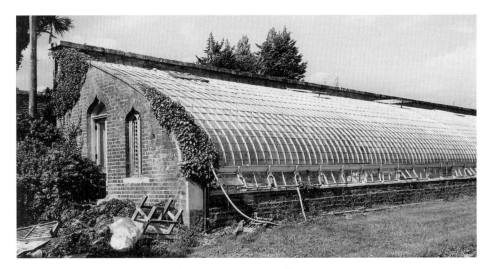

Present walled gardens and glasshouse in Mount Anville.

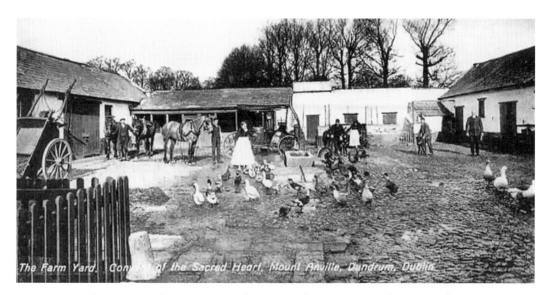

Farmyard at the rear of Mount Anville demesne in the early twentieth century.

there is a large, courtyard-style hall in the centre, two storeys high, lit by a large dome-like roof light. The various rooms open off the inner hall, and a gallery on three sides at first-floor level, with attractive cast-iron balustrade, provides an attractive focal point, as does the matching staircase. The main ground-floor rooms have mahogany-panelled doors, carved architraves, ornate plaster cornices, and other plaster features, in addition to some lovely marble fireplaces. The three east rooms on the ground floor have sliding interconnecting doors, so that one very long room can be created for parties and the like.

Mount Anville Primary School

The Ladies of the Sacred Heart (a title used for many decades to distinguish them from lay people) bought Mount Anville in 1865 and immediately began building a very large boarding school, much too large for their thirty girls but intended for a future expansion in numbers. They also set up an

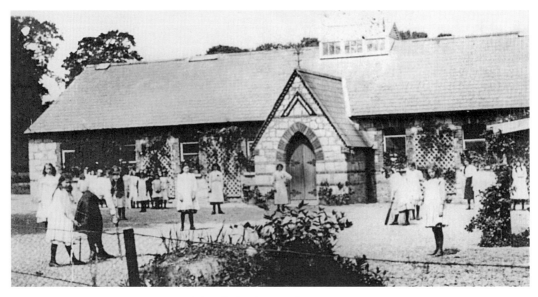

Mount Anville National School, beside the farmyard.

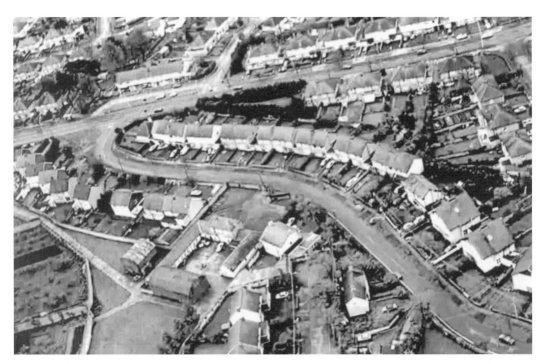

Aerial view showing Mount Anville farmyard near Lower Kilmacud Road. Part of the walled garden is visible on the lower left.

'extern school' for poor children, although there were enough National Schools in Stillorgan and Kilmacud. A room in the single-storey farmyard buildings was chosen for the school, but a large extension was added in 1870. The nuns obtained Board of Education approval in 1879, and thereafter the government paid all of the school bills and salaries. The archives of the Board record the facilities in 1879, the school being single storey and slated, with three interlinked rooms (one unused), sized 49ft by 24ft by 10ft high; 20ft by 24ft, and 19ft by 24ft. Two untrained nuns did the teaching, five days a week, four and a half hours each day, and the pupils paid 1 *d* per week. Ten boys and sixty-four girls were present on the date of inspection, although there were nineteen boys and ninety-two girls on the roll book.

The Board archives record an average attendance of 130 pupils in 1926, and this seems to have been the norm up until the mid-1950s. In 1926, there was one nun and two lay assistants, although Sr Stewart ran into problems with the Board because she was not qualified to teach Irish, so important after the founding of the Irish Free State.

One of the nuns who taught here in the late 1940s has fond memories of the school, but doesn't miss the smell of pigs from the adjoining farmyard. She recalls that two groups of pupils were taught by two different teachers in the one room, with half of the pupils facing one way and the rest facing the other way. One class did vocal work while the other did quiet work, and then they reversed roles. Each group comprised different classes (e.g. third and fourth class would all be in the same group).

In 1955, the school moved to new, purpose-built premises on a four-acre site a few hundred metres further to the east, along Lower Kilmacud Road, in a part of the nuns' farm known as Botany Bay. This is a single-storey slated building with two long wings housing the classrooms and a hall in the centre. The woodblock floors are still in the classrooms and the hall, and coloured terrazzo screeds in the corridors. The various corridor walls (and some ceilings) are beautifully decorated with colourful floral scenes, which add to the homely nature of the school. There is also a playing yard and a small vegetable/flower garden. The rear disused field would cater for future

All that remains of Mount Anville farmyard. The building on the right was part of the National School.

expansion. Pupil numbers increased to 402 in 1957 and rose to 700 in the 1960s, but dropped to 300 in 1990. After enlarging the original classrooms in 2009, the school now caters for 415 girls, aged four to thirteen, looked after by twenty teachers and two special needs assistants. Infant boys were catered for in the early years of the new school building, but this stopped around 1999. Many of the girls go into the fee-paying senior school after a free education in the primary school. The primary school uniform includes a tartan skirt, to distinguish the girls from the fee-paying junior school.

Part of the historic farmyard and old national school is still in existence. The 1870 part of the school was demolished to pave the way for new houses in Mount Anville Lawn in the 1970s, but most of the original room from 1865 is still there and is used as a store. The south side of the farmyard buildings is used by the family of one of the convent workmen, although the centre archway has been converted into a room and an extra storey was added in the 1950s.

Scoil San Treasa

After the parish priest of Dundrum purchased Mount Merrion House in 1935, he resolved to set up a small primary school in the north wing of the old mansion house. The south wing of the old mansion was converted in 1935/6 into a chapel of ease, with curate's residence directly overhead on the first floor. By 1939, the architects, P.J. Munden, had been commissioned to turn the four first-floor rooms into three classrooms and a teacher's room, and part of the ground floor into separate boys' and girls'

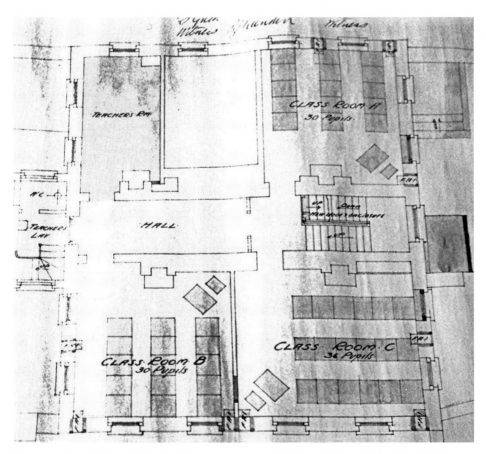

The rear wing of Mount Merrion House was converted into a National School in 1939. There were three first-floor classrooms.

Clár Ama.

	Dia luain	D. Máirt	D. Céadaoin	Dardaoin	Dia h-Aoine
9.30 – 10	Gaedilg	Gaedilg	Gaedilg	Gaedilg	Gaedilg.
10 – 10.30	"	"	"	"	"
10.30 – 11	Áireamh		Composition	Áireamhidheacht	Áireamh
11 – 11.30	"	English	"	Áireamh	"
11.30 – 12		Teagasg Críostaide			
12 – 12.30			Sos.		
12.30 – 1	History	O. Snáthaide	Geography	Algéabar	Gaedilg.
1 – 1.30	"	"	"	History	
1.30 – 2	Algéabar.	Áireamh	Áireamh English	Áireamh	English
2 – 2.30	English	History	History	English	History
2.30 – 3	Geography [Eolas ar Nádúr]	Geography	Algéabar.	Grammar	Algéabar

Typical National School timetable in the 1930s.

An tSeisiamh dar críoc 1ad M.F. '39.

Gaedilg léigeam, litriú, leac 3 ⁊ 4.
———— Cómrád
(a) Is, 'seadh, ní h-eadh.
(b) An Cailín féin.
(c) Sgéal: Seán ⁊ an Leipreacán.
Scríobadh: cinn línte; áit-sgríobadh.

Béarla Reading, Spelling and Explanation
———— Reader Page 13, 14.
Writing: Headlines, Transcription,
Word-Building.

Áireamh Cleachtadh ar suimiú ⁊ dealú. *
———— Táiblí Méadaigthe a ceartaú.
Obair béil. Fadbanna simplide.

* 75 + 57 | 75 57 132
 57 57 18
 132 18 11 4 . fr. 114.

Typical National School syllabus from the 1930s.

cloakrooms and toilets. Classes A and B were intended for thirty pupils each, while Class C was for thirty-six pupils.

The decision was taken to build a new primary school to cater for the additional houses built in Mount Merrion in the post-war years. Scoil San Treasa opened in 1963, with its hall and two-storey class block facing the back wall of the church, and a two-storey service block linked to a single-storey west classroom block beside North Avenue.

Oatlands

The old Oatlands House and thirteen acres was part of a larger estate leased by the Emmet family from 1799, but when the Landed Estates Court sold the entire estate in 1880, the owner was Richard Guinness Hill, and Oatlands was leased to Thomas Fry for eighty-five years from 1808, at a rent of £92 6s 2d per annum. The house was obviously sub-let, since Matthew Pollock occupied it from 1840 to 1910; in fact he bought it from the Landed Estate Court in 1880. Later occupiers included: solicitor Fred Darley, from 1910 to 1916; Sir John Ross, Lord Chancellor, from 1916 to 1926, and Peter O'Connell, from 1926 to 1951. Pollock is probably the most famous occupier, being a partner in the wholesale drapers Ferrier & Pollock, who owned Powerscourt House in South William Street from 1835 to 1981, when it was sold and converted into a chic shopping centre.

The Christian Brothers bought the property in 1951 as a home for themselves and a fee-paying secondary school, seeing Mount Merrion as an affluent locality and bearing in mind that secondary education was not the norm in that era. The school opened that same year, with fourteen boys in first year and four boys in second year.

By 1953, a new two-storey school was opened alongside the old house, and this operated as both a primary and secondary school, until a separate secondary school was opened beside the Stillorgan Road in 1955. The builder, Geraghty, presented the Brothers with an engraved silver key.

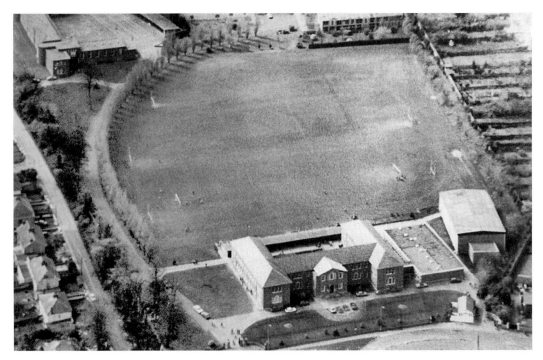

Aerial view of Oatlands. The secondary school is at the front, with the National School rear left, and 1960s monastery rear right. (Courtesy of Christian Brothers)

When free secondary education was introduced in 1967, the Brothers expected a boom time, and so built themselves a new, modern monastery beside the old house. The architect, Ronnie Tallon, designed a flat-roofed box building with a small internal courtyard, all enclosed by glass. The house catered for twenty-eight brothers and two maids, cost £106,000, and was opened in 1968. Later that year, the old mansion house was demolished.

4

SHOPS AND BUSINESSES

Mount Merrion Gardens

Few will remember this name, and might be surprised to learn that it was, in fact, a terrace of shops on the main Stillorgan Road, where Priory Hall offices now stand. These shops were built in 1935 to cater for the newly emerging Mount Merrion estate houses. It must also be remembered that the main Stillorgan Road was much narrower than today, and had very little traffic up until the early 1970s. Prior to the advent of supermarkets in the 1960s, people walked to the local shops every day, buying fresh meat in one, vegetables in another, and so on. In addition, the big bakeries delivered fresh loaves of bread daily to your house (there was no sliced bread!) and milk bottles were left on your doorstep early every morning, after you had left out the empty glass pint bottles the night before.

The range of shops in Mount Merrion Gardens in 1965 gives a good idea of the services available, bearing in mind that Ireland's first shopping centre, in Stillorgan, wasn't opened until the following year. First was Bain, the chemist, followed by McGarry, newsagent and tobacconist. Then you had McDonagh, the butcher, and Lennon's shoe repairs. In those days, you didn't throw away your old shoes: you had them 'soled and heeled', making

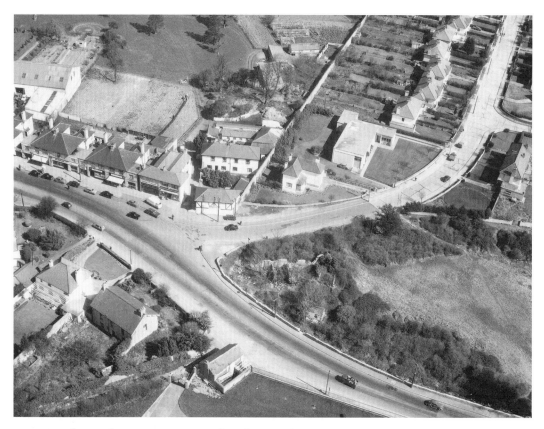

Aerial view of Mount Merrion Gardens shops on the N11, with Priory Drive at top right, 1964. (Courtesy of the National Library)

them nearly new again. The famous Findlater's occupied two shops, and you bought all your groceries here. Everything was stocked on shelves behind a long counter, behind which stood the grocer, and he took your shopping list (or you shouted out what you wanted) and filled your leather or canvas shopping bag with your packets of loose tea leaves, bags of sugar, biscuits, eggs, jam, cheese, etc. Your slices of ham, corned beef and haslett were cut on the spot. Sometimes you didn't pay that day; instead your account was noted in a big ledger and you 'cleaned your slate' on Friday – payday. Findlater's had a branch here (one of many throughout Dublin, mostly larger) from 1950 to 1968. Next to Findlater's was the Royal Bank

Mount Merrion Gardens in the 1970s, opposite the bottom of Trees Road. (Courtesy of Dún Laoghaire-Rathdown County Council)

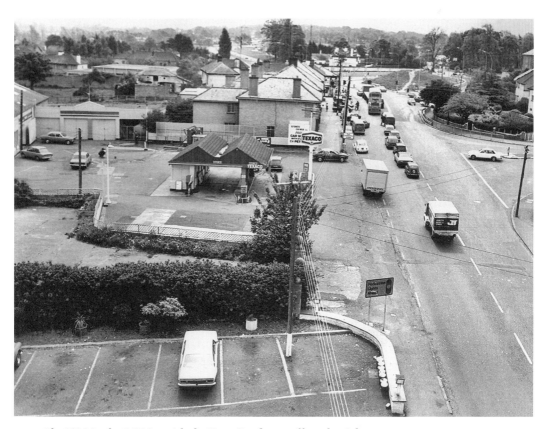

The N11 in the 1970s, with the Trees Road turn off on the right.

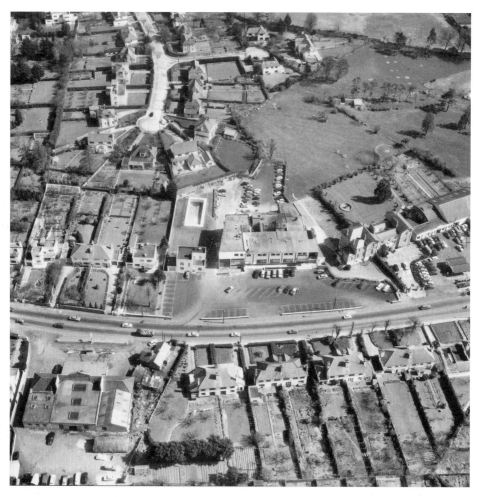

Aerial view of the N11 in the 1970s, at the South County Hotel (now Stillorgan Park Hotel). Note the outdoor swimming pool to the left of the hotel. To the right of the hotel is another Mount Merrion House, which by this stage was split into two separate ownerships. Part of the Texaco garage is to the right of the house. The field at the rear right became the Mount Merrion Pitch and Putt Club. In the front left is Noel Gleeson Garage (later Esso), and there is an old Mount Merrion House lodge on the right of the forecourt.

Opposite View of N11 at the South County Hotel (now the Stillorgan Park Hotel), 1970s. Note the Esso garage on the left and the old Pembroke lodge to the south of the garage.

of Ireland, beyond that Miss Lennon's, the sweetshop, Gerald Keegan occupied The Gables next door, and finally, Swiss Cleaners, dry cleaners.

To the north of Mount Merrion Gardens was Mount Merrion Motors Ltd (later called Safety Service Station, and recently Texaco), who were mainly dealers for Opel and NSU, and had over fifty used cars for sale. Some readers will remember the NSU Prinz 4, an early 1960s model. In those happy days, the garage stayed open until 10p.m. each evening (6 p.m. on Saturday).

The Gables, bought in 1938 by the Keegans, was in fact a farmhouse with six acres attached. Prior to this purchase, the Keegans sold their Swift car distribution business in St Stephen's Green, which also supplied all the timber-framed vans for Bewley's coffee. Keegan's fields accommodated a few cows, but the main business was pigs (about 100) and around 4,000 caged battery hens, in addition to some market gardening (potatoes, etc.). The new N11 in the late 1970s heralded the demise of Keegan's, when Mount

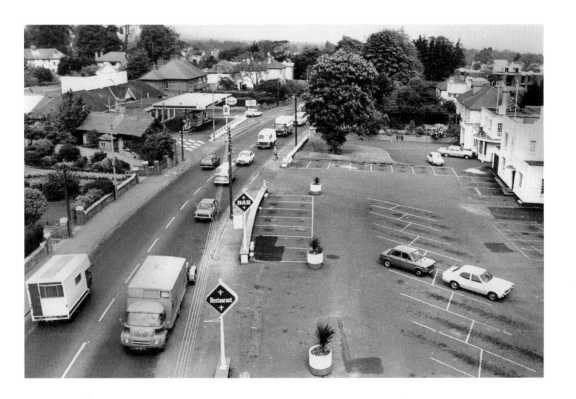

Merrion Gardens was compulsorily purchased by the County Council and then demolished. In 1990, the shop site and part of Keegan's fields were developed by Guardian Builders as Priory Hall, comprising about 2,700m² of offices in two three-storey blocks, subdivided into small own-door office units, in addition to a central two-storey car park. In the mid-1990s, the last parcel of land was developed as Treesdale, an estate of forty-one houses. Parts of the old high stone boundary wall between Keegan's and the former Stillorgan Priory can still be seen around Treesdale (see 'Mount Merrion Pitch and Putt Club', p.109).

Just down the road from Mount Merrion Gardens was Ashurst Garage, a Fiat dealer, and until recently a Shell petrol station. A new Applegreen petrol station was built in early 2010.

Diagonally across from Mount Merrion Gardens was Noel E. Gleeson Ltd, a Volkswagen dealer and Esso petrol retailer. Noel lived in the house on the north side of the garage, called Dandenong. The garage, including two small shops, was built in 1935, at the same time as the Greygates houses, and was originally owned by Eames and called Estate Garage (it is still called Estate Service Station). Noel, a rally car driver, acquired the business in the early 1950s and expanded it in the 1960s by setting up the Stillorgan Ambulance Service. He had five private ambulances on the road, operating from Stillorgan to Wexford, including Dublin's only cardiac ambulance, which catered for about ten patients a week. In the late 1970s, Esso acquired and demolished Gleeson's, introducing the modern canopied forecourt, which has undergone several changes in appearance since then.

On the south side of Gleeson's forecourt was a single-storey cottage, which was demolished by Esso in 1981. This was a gate lodge for the Fitzwilliam/Pembroke demesne, alongside a diagonal avenue leading to the farmyard. The lodge had granite rubble walls with cut quoins, brick window dressings and a slated roof. The last occupier was Miss O'Connor.

The Rise

A small collection of shops was built on The Rise in the mid-1930s as part of John Kenny's estate and these included a grocer's. John Meagher ran the original main grocery shop, superceded by H. Williams in the 1950s, and this company later developed into a famous supermarket chain. The Mount Merrion branch then became a Super-Valu outlet in the 1980s, which continues to expand on the site. These days, the other shops include a newsagent/post office, a chemist, a small flower shop, and a small dry cleaner's.

Further up The Rise is No.93, a small estate of offices now leased by Biotrin International, a diagnostics company specialising in tests for infectious diseases. John Du Moulin owns the estate and used it in earlier decades as his builder's yard, especially when he built the new Catholic

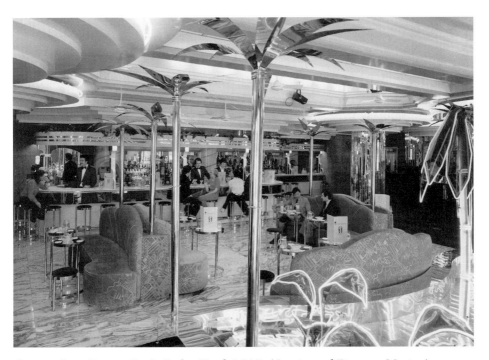

Coconut Grove Lounge Bar in Parkes Hotel, 1987. (Courtesy of Finnegan Menton)

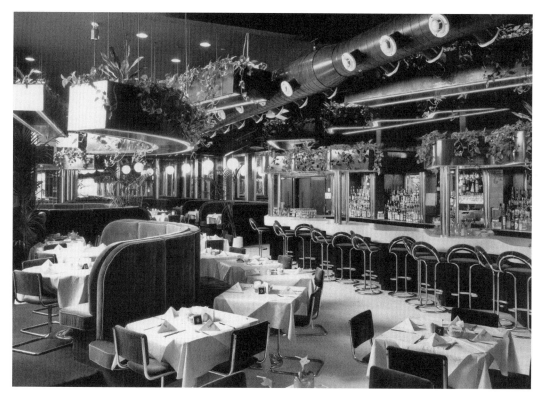

Peppermint Garden restaurant in Parkes Hotel, 1987. (Courtesy of Finnegan Menton)

church in 1956. The two-storey offices are stone built, with slate roofs, and date from the mid-eighteenth century, when they were the stables for Mount Merrion House. The north wing was demolished in the 1970s by the parish priest after an earlier fire, but you can still see some parts of a wall, at the rear of the Scout Hall.

Deerpark Road

A substantial group (in fact, two groups) of shops was built in the early 1960s, and the newsagent, Ed McGuire, is still going strong and is much loved by all children in the area, because of his 'penny sweets'. Nowadays,

there is a furniture shop, a chemist, a butcher, a florist/greengrocer, a hairdresser, a ladies' boutique, and a wine shop/deli-cum-restaurant, in addition to various offices above the shops.

Trees Road Upper

A small group of shops was built in the early 1960s, and nowadays there are two ladies' hairdressers, a chic café, a grocer, chemist, solicitor, and bicycle/lawnmower shop.

Glenville Industrial Estate, 26 Foster's Avenue

This estate, comprising about an acre of land, is a secluded low-rise terrace of factory buildings dating from the early 1960s, which were

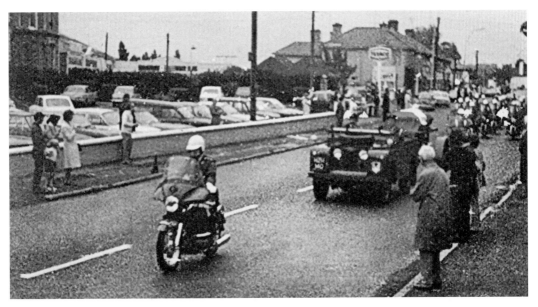

President de Valera's funeral cortege passing the South County Hotel, 1975.

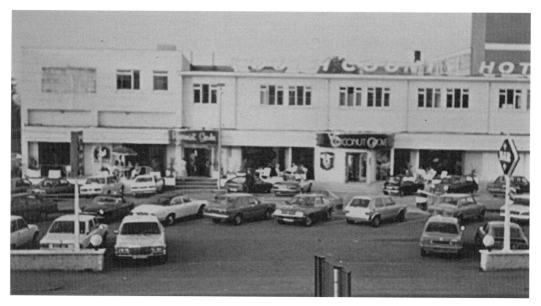

South County Hotel, 1975.

partly occupied by Smith & Nephew-Southalls (Ireland) Ltd, probably for warehousing, and later by RTÉ to store props, etc.

Motor Import Ltd occupied part of the estate from 1967 to 1973, and in fact, this is where the story of BMW cars in Ireland began. Frank Keane was the General Manager of Mount Merrion Motors (later Texaco Garage) in the early 1960s, and after a spell with the Three Rock Garage in Rathfarnham, he started his own company, with two co-directors, importing these luxury car from Germany and selling them through approved car dealers. Bayerische Motoren Werke (Bavarian Motor Works) is located in Munich. The first models, including the top-end Tilux, ranged from 1.6 to 2.0 litres, with prices of £1,675 to £2,500. Motor Import Ltd later moved to the Naas Road.

Nowadays, the estate is disused, awaiting redevelopment. The adjoining house is also called Glenville, built in the early 1930s for Dr John Ralph. It is two storey over semi-basement, with a hint of a nautical theme in its appearance.

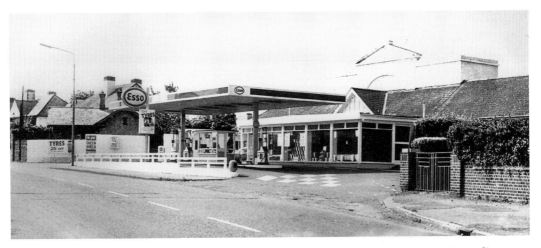

Esso Garage on the N11, 1970s. (Courtesy of Dún Laoghaire-Rathdown County Council)

Former Foster Motors

This started off as Eames Garage in the early 1960s (presumably the same family who owned the garage where Esso is now located in Greygates). In the late 1960s, it was called Eames & Wynne, and it remained as such until the mid-1990s, when Foster Motors was established, specialising in Volkswagen and Audi cars. These days, the showroom is in Stillorgan Industrial Park.

Stillorgan Park Hotel

Mount Merrion House, the Irish seat of the Fitzwilliam/Pembroke family, was *the* 'big house' in the locality, but another late-Georgian property on the east side of Stillorgan Road also aspired to grandeur, and was given a similar name, although it only had a small plot of land. The original three-bay, two-storey-over-basement house was extended on both sides, probably in the late nineteenth century, thereby making it quite imposing

Stillorgan Road/N11 in the 1970s, looking towards city, with Shell Garage on the right. (Courtesy of Dún Laoghaire–Rathdown County Council)

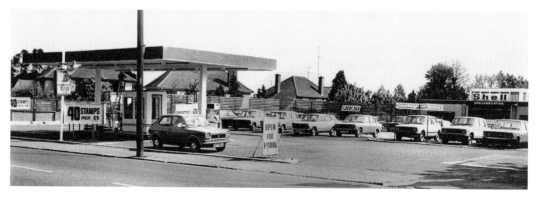

Shell Garage in the 1970s – now Applegreen Service Station. (Courtesy of Dún Laoghaire-Rathdown County Council)

Former Greygates Filling Station at the bottom of The Rise – now Fitzwilliam Court apartments. In the 1950s they sold caravans, such as a Shannon model for £385.

and very visible from the main road. The Murphy family ownership extended back a few generations, but by the 1930s the house had changed hands, and in fact, the north wing was separated and renamed Hopetown House.

Pascal Vincent Doyle (or P.V., as he was more commonly known) heralded the Swinging Sixties, when Jack Lynch, Minister for Industry and Commerce, opened P.V.'s small South County Hotel in June 1961. P.V. was born in 1923, and started his building career working for his father's company, Frankfort Estates, in Dundrum. P.V. built houses in the 1950s, such as beside Terenure College, Orwell Road, Fortfield Road, and St Brigid's in Clonskeagh. His first big project was the County Club in Churchtown in the late 1950s (later called the Braemor Rooms, and then McGowan's). Next, he bought Hopetown, the north wing of Mount Merrion House, and some land attached, and he built a detached, two-storey hotel, called the South County Hotel. Hopetown (Holdings) Ltd was the company involved, and the seven-day drinks licence was transferred from a Cork pub.

There were twenty bedrooms on the first floor (none *en suite*), while the ground floor was laid out as a lounge with corner bar, a much larger central cocktail-cum-coffee lounge (the Green Room), a dining room, kitchen and small residents' lounge. A special feature was the 62ft by 22ft open-air swimming pool at the rear of the hotel. There was a massive 22ins television in the reception, and an 80ft high aerial on the roof. Bed and breakfast cost 32*s* 6*d*, and you could enjoy a four-course lunch for 5*s* 6*d* in the Steak Grill. Saturday evening dances were very popular.

Within a year, P.V. had sold the hotel to Irish Cinemas Ltd/Rank Organisation for £100,000, and he went on to bigger and better hotels, such as the Montrose in 1964, the Burlington in 1970, eventually building up Ireland's most famous hotel chain. Incidentally, Irish Cinemas Ltd, so long associated with the Elliman Brothers, closed down the famous Theatre Royal in Hawkins Street in 1961, thus ending the wonderful days of a variety show combined with a film.

The South County was extended in 1965, at a cost of £180,000. It could now boast seventy centrally heated bedrooms, with telephone, shower and some private baths, in addition to a Merrion Suite with seating capacity of 300, suitable for wedding breakfasts. Bed and breakfast was now £7.

In the 1970s, the hotel had mixed fortunes, and even lost its drinks licence from November 1974 to May 1975. Then it reopened, coinciding with the start of the disco era. However, further changes were afoot: the exotic Parkes Hotel opened in 1982, comprising the 4,500ft^2 lounge bar Coconut Grove, the 2,500ft^2 Peppermint Garden Restaurant, and the 8,500ft^2 Flamingos Night Club. There were forty double/twin bedrooms and seven staff rooms, all *en suite*. This venue was really glamorous and lively, and even featured 'bunny girls'. 'Rock Fox' and his jazz band performed there regularly.

In 1987, Parkes Hotel was sold for £2 million to businessman Sean Quinn after the demolition of the old Mount Merrion House, which still stood, all boarded up, between the hotel building and the Texaco garage. The hotel, now called the Stillorgan Park Hotel, went into decline

(including the night club), and by 1996, it was purchased by the Pettit family from Wexford. They practically rebuilt and greatly enlarged the property, upgrading it to four-star status, catering largely for conferences, weddings and coach tours, with 165 air-conditioned bedrooms. The present large reception and foyer, large Turf Club lounge bar and Purple Sage restaurant have very colourful and lively décor and furnishings, with emphasis on yellow and purple, the official colours of the Wexford football and hurling team, who have made the hotel their base when occasionally playing in Croke Park.

Devotees of the rock band Def Leppard will no doubt have enjoyed their 1986 album *Hysteria*, and in particular the track 'Pour Some Sugar on Me'. The accompanying video shows the band playing amidst the shell of Mount Merrion House, while it was actually being demolished by a 'ball and chain'.

Stella Ballroom

David Ronald Whitren is the businessman who built Stella House in the late 1950s. He had planned to build it across the road, on the site of the present children's playground, but it was deemed to be too near the new Catholic church. David, an electronics engineer, was born in Canada in 1925 and came to Ireland in 1952. His original building comprised twelve flatlets, a dance hall, and two businesses: Irish Television Maintenance Ltd and Electricraft Ltd.

In the 1960s, and to a lesser extent in the 1970s, the Stella Ballroom attracted up-and-coming bands, such as Them from Belfast, which included Van Morrison in the line-up. David also managed his own band called The Stellas, a variation on the showband set-up, featuring guitar, rhythm guitar, bass guitar, keyboard, drums, tenor saxophone, baritone saxophone, etc. In those days, there was no alcohol available in ballrooms, and this trend continued for some decades.

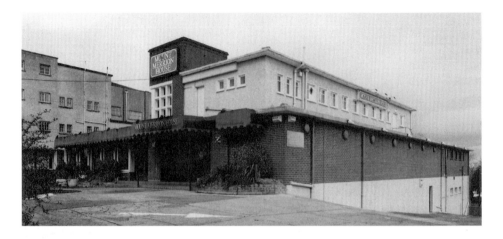

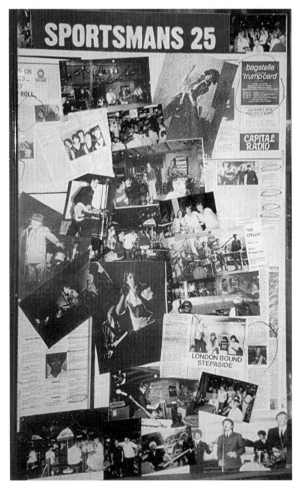

View of the former Stella Ballroom, 1989. Pitched roofs were added by later owners. It is now Kielys Pub.

In the early 1980s the pub was called the Sportman's Inn, popular for soft rock music gigs.

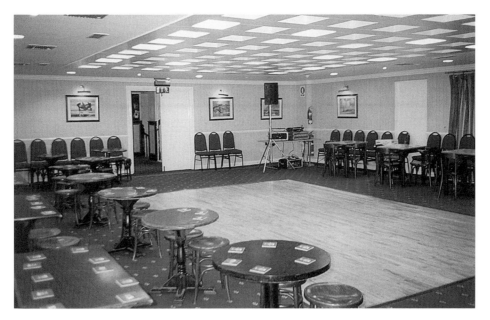

From the mid-1990s, the first floor of Kielys pub, called 'Cheers', held weekly adult dances, organised by DJ Mike Fallon.

Then the venue became a public house called the Sportman's Inn (1980-1986), still operated by David Whitren, and was very popular for music gigs, featuring such Irish bands as Full Circle.

From 1986 to 1993, the pub was called Mount Merrion House, and owned by Toby Restaurants, a subsidiary of Bass, a large British brewery. Toby completely modernised the premises and greatly improved the outside's 'boxy' appearance by putting red-tiled pitched roofs over the various flat roofs. The different areas had familiar titles, such as, the Rise Lounge, the Cedar Room (a small function room), the Summit suite (a function room on the first floor) and the Fitzwilliam Restaurant, on the lower ground floor. There was outside parking for 120 cars.

By the mid-1990s, the pub had again changed hands, this time to Kielys of Donnybrook, who naturally enough renamed it Kielys. They created a separate bar, fitted out exactly as an old-time bar, with very little in the way of creature comforts. Adult dances were held at weekends in the first-floor

function room (called Cheers). These dances were organised by popular DJ Mike Fallon for about eighteen years, but ceased two years ago due to competition from hotels holding afternoon tea dances. The basement restaurant seems to change hands periodically, from Peking cuisine to Thai, to Chinese, and so on. Recently, music gigs have returned to the main lounge, and Full Circle are back again to entertain the crowds. There is now a small music museum in the front of the lounge.

Stella Cinema

Just to confuse matters, the adjoining premises was a large 1,000-seater cinema called the Stella, built in 1955 by the O'Grady family, who also owned the Stella cinema in Rathmines. The first film was *Ring of Fear* (about a circus), starring Clyde Beatty and Mickey Spillane, and admission prices were 1*s* 6*d* for the stalls and 2*s* 6*d* for the balcony. The following week, *Valley of the Eagles* was shown, supported by *Cave of Outlaws*. In the mid-1960s, a typical show might be *I'm All Right Jack* supported by *Two Way Stretch*, both starring Peter Sellers. In the mid-1970s, a good evening out could comprise *Deliverance* supported by *Dirty Harry*.

The 1970s saw the demise of many suburban cinemas, or subdivision into multiplex screens, largely because the price of television sets dropped and most houses could now afford to buy a colour television set. The Stella closed in October 1976, with a final showing of *Earthquake*, starring Charlton Heston, Ava Gardner and George Kennedy. The building was then acquired by Flanagan's of Buncrana, an upmarket household furniture shop, which was founded in Donegal in 1946. They did not alter the building, and you can still see the ornate 1950s plasterwork, some terrazzo flooring, and even the letters 'S.C.' on the floor in the porch. The present display windows were originally two little shops, unconnected with the cinema – some people might remember Speight School of Motoring in the left-hand shop.

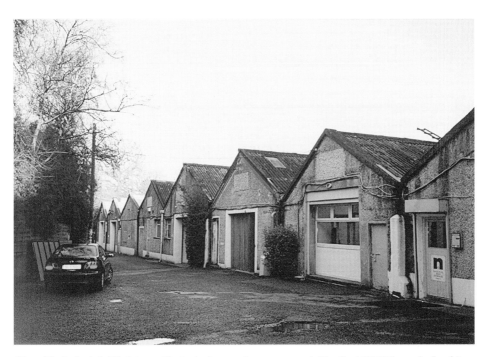

Glenville Industrial Estate on Foster's Avenue is now vacant. The first BMW car dealership in Ireland started here in the 1960s.

Dublin City Marathon at the top of Foster's Avenue, October 2007.

Beaufield Mews

Nowadays, Beaufield Mews is famous as an 'olde worlde' restaurant-cum-antiques shop/art gallery, because of the good food and superb rear garden, but part of the attraction lies in the patchwork of old buildings, which in fact were the coach house/stables for the main mansion house, Beaufield.

The twenty-five-acre Beaufield estate was originally part of a larger estate under an old 1799 Robert Emmet lease, and extended down to the present Kilmacud Road, but did not include the main village of Stillorgan (the present shopping area), which was held by others under a separate lease. The properties on the Kilmacud Road included Garnaville Cottage and Ornee Cottage, and some smaller cottages called Beaufield Place, in the vicinity of the present Stillorgan Décor.

The early Victorian house was similar in design to the nearby Oatlands, except smaller (three bays wide). Different families rented and owned it over its life, including Henry Darley, Patrick Sweetman, Martin and Comyn. In fact, Thomas Shannon Martin bought the house in 1881 from the Landed Estates Court. In 1936, the county council acquired, by compulsory purchase, a plot of eight acres alongside Kilmacud Road,

Saorstát Éireann letterbox at the top of Foster's Avenue.

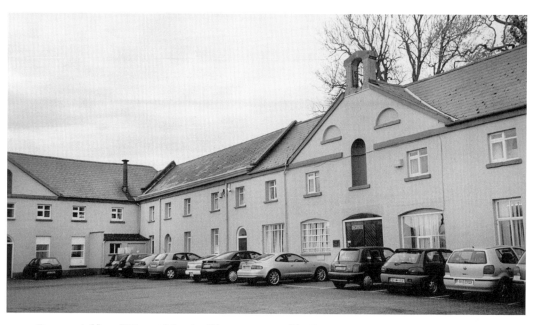

Former stables of Mount Merrion House, now used by Biotrin.

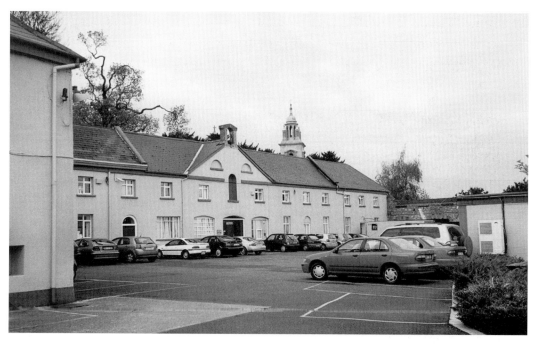

Another view of the former stables of Mount Merrion House, now used by Biotrin.

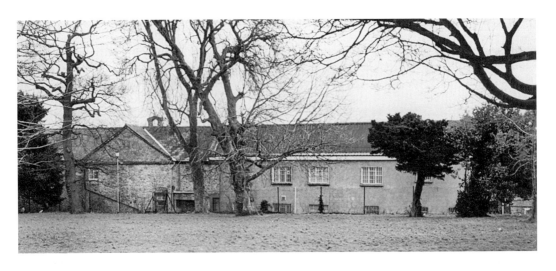

Recent west elevation of the former stables of Mount Merrion House.

On the north side of the former stables are the remains of an old wall, which was the north wing of the complex and housed The Barn club. The modern Scout Hall is on the far side of this wall.

Jill Cox, Paddy Rice and Julie Cox outside Beaufield Mews Restaurant in Woodlands Avenue, 2010.

Beaufield Mews restaurant, still going strong, 2002.

where they built a spacious estate of sixty-eight workers' two-storey cottages, Beaufield Park.

The Kirwan family acquired the remainder of the estate, including the main house and stables, from the Wilsons in 1938, and subdivided the house into apartments. Valentine Kirwan was a solicitor, and in the 1940 and '50s he sold off parts of the estate to developers, who built the houses in Woodlands Avenue, etc. Then his wife, Doreen, converted the stables into an antique shop in 1948; she added a coffee shop in 1950 and expanded the coffee shop into a restaurant about ten years later.

Following a fire in 1987, the Kirwans sold the main house to a developer, who demolished it and built thirty-three town houses and bungalows, called Beaufield Manor. Doreen's granddaughter, Julie Cox, now runs the restaurant, while Doreen's daughter Jill Cox runs the first-floor antiques shop. Jill still maintains the wonderful garden, which is colourful all year round, but especially in August, when the flowers rival those of the Chelsea Flower Show. The head waiter, Paddy Rice, is still as efficient and good humoured as ever, after more than forty-three years' service – his motto is, 'Do it nice, or do it twice!'

The entire building complex, including the restaurant, is an ever-changing art gallery, where living artists display their creativity, usually at reasonable prices. The restaurant was modernised in 2007, in the hope of attracting a more affluent, younger clientele, while still pleasing the regular older set, especially the family groups who have enjoyed Sunday lunches there for the last twenty years.

5

HOUSES

St Helen's Hotel

Opened in 1998 as a five-star Radisson Hotel, with 150 air-conditioned bedrooms in a modern extension, this property has an interesting history, dating back to the early 1750s, when Thomas Cooley, barrister and MP, built his house in open countryside on land belonging to the Fitzwilliam family, naming it Seamount, because of its high elevation overlooking the Dublin coastline. A map of 1783 shows Mrs Ford in occupation; she was leasing it from Robert Alexander, Justice of the Peace and High Sheriff of Dublin, and she was still there in 1830. John Doherty, MP and Lord Chief Justice of the Common Pleas, was the next occupier. The Rt Hon. Thomas F. Kennedy was in possession in the late 1830s, and he changed the name from Seamount to St Helen's. Colonel Henry White was the occupier in the 1840s.

Around 1850, the property was acquired by Sir Hugh Gough, its most notorious occupant. From Woodstown, County Limerick, he joined the British Army in 1792 at the age of thirteen, and first gained recognition in Spain and Portugal during the Peninsular Wars (1808-1814). He was wounded at Talavera in Spain when the British were forced to retreat.

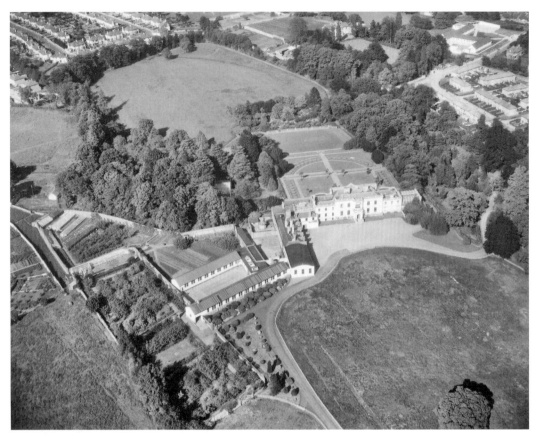

St Helen's House, 1956. (Courtesy of the National Library)

He was pensioned off in 1815 but was later involved in quelling 'unrest' in the Munster region during the fight for Catholic emancipation in the early 1820s. In the 1840s, he resumed his army exploits, this time in India, but was no match for the Sikhs and hence had to be replaced by Sir Charles Napier, after which he returned to Ireland and purchased St Helen's.

Gough extended and altered St Helen's in 1863, but he died in 1869, aged ninety, and is buried in the family plot in St Bridget's graveyard in Stillorgan (Church of Ireland). Because of its British Empire connotations, the Gough equestrian statue in the Phoenix Park, which stood on the main road near the Hollow, was blown up in 1957. The bronze statue, cast in

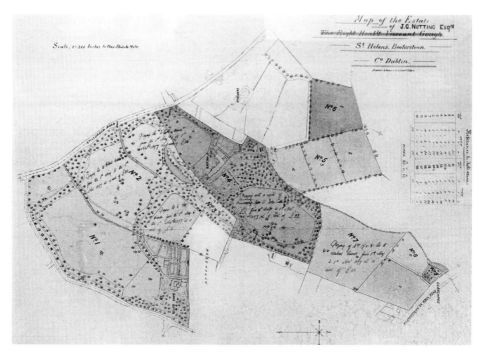

A map of St Helen's House estate, with Rock Road on lower right and Stillorgan Road along the top. (Courtesy of Irish Architectural Archives)

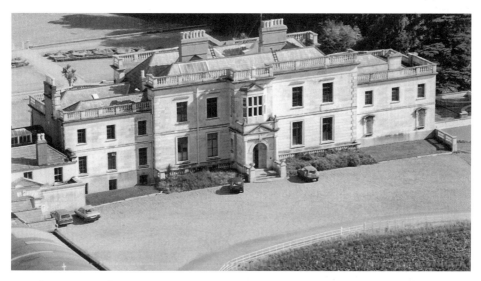

St Helen's House when owned by the Christian Brothers. (Courtesy of Irish Christian Brothers)

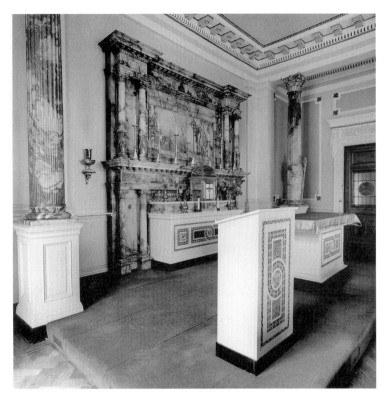

The ballroom of St Helen's House was converted into an oratory by the Christian Brothers. It is now the hotel lounge. (Courtesy of Irish Architectural Archives)

London in 1880, was the work of acclaimed Irish artist John Henry Foley (born in Foley Street in inner-city Dublin), who also created the wonderful O'Connell monument on O'Connell Street. The Gough statue was restored, at great expense, and then sold by the government in 1984, ending up in England two years later.

St Helen's then came into the hands of Sir John Nutting around 1899. In 1905, two years after he was made a baronet, he clad the original brick facades with white Portland stone, and embellished the hall and ballroom with exquisite marbles. The original eaves were hidden behind a bottle balustrade and the newly acquired coat of arms displayed on the front and rear pediment, comprising a half eagle-half lion enclosed between two nut branches, with the motto, '*Mors Potior Macula*' ('Death rather than Disgrace').

The 1901 Census records that forty-eight-year-old John G. Nutting was a Protestant export merchant, and that his son and daughter were present in the house, aged eighteen and twenty respectively, plus a governess and two young visitors. There were also two footmen, five house maids, two kitchen maids, one cook, one lady's maid, and two laundry maids. The main house had twenty-four front windows and forty rooms. There were eight other small cottages on the estate, occupied by two gardeners, two stable men, one herd, one butcher and one labourer. The outbuildings included two stables, one coach house, two harness rooms, one cow house, one calf house, one piggery, one barn, one potato house, one workshop, three sheds, one forge, one laundry, and one electric-engine house.

The original estate was ninety-three acres, extending from the old Stillorgan Road to the Rock Road, and the magnificent mansion and estate was bought in 1924 by the Christian Brothers to be their provincial

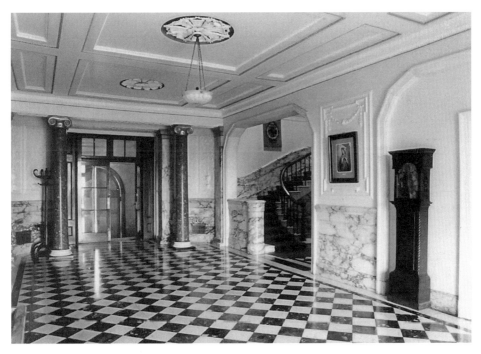

The hall of St Helen's House. (Courtesy of Irish Christian Brothers)

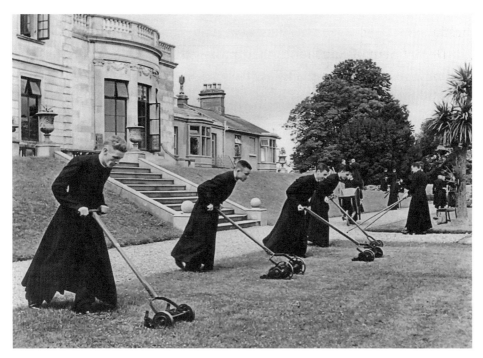

The rear of St Helen's House. (Courtesy of Irish Christian Brothers)

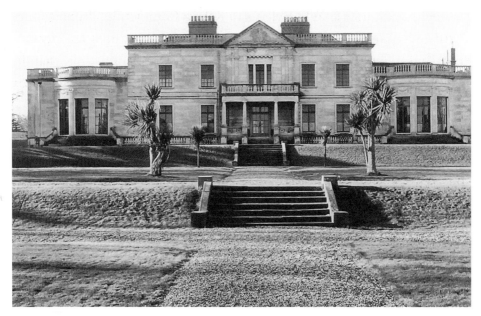

Another view of the rear of St Helen's House. (Courtesy of Irish Christian Brothers)

headquarters and training Novitiate for new recruits. In conjunction with the Department of Education, they managed National Schools for boys, and various orphanages, such as Letterfrack in County Galway and Artane in Dublin. Almost immediately, the Brothers sold off about nineteen acres abutting the Rock Road, where G. & T. Crampton Ltd built houses on St Helen's Road in the early 1930s. These houses had three or four bedrooms, a garage and an average price tag of £1,085. By 1947, the Brothers had sold part of the sublet estate of Sans Souci (but retained the stables), after which that house was demolished and a small estate of houses built. Sans Souci was once the home of the Digges La Touche family, famous Huguenot (French Protestant) bankers. The Pembroke estate records that in 1830, William Digges La Touche had a lease for ninety-nine years from 1802, but had sublet to Robert Roe, and that the three-storey mansion was of the most superior class.

The late 1960s brought a sharp decline in vocations to the Christian Brothers, so the Novitiate moved to Bray and St Helen's was used only as the Provincialate. Shortly after moving to York Road in Dún Laoghaire in October 1988, they sold St Helen's to Rohan Commercial Properties, as agents for Phoenix Properties. The estate at this stage was seventy-one acres, but included No.115 and No.117 Booterstown Avenue, which the Brothers had previously bought with a view to demolition and opening up the estate for development purposes. The Brothers obtained £5.15 million for the property, and the signatures on the contract were Jeremiah Columba Keating, Phillip Kevin Skehan, Cornelius Fidelius Horgan, and Thomas Peter Cronin.

Various developers and builders got involved in providing houses and apartments such as Fosterbrook, Seamount, Merrion Grove, Belfield Park, and St Helen's Wood. St Helen's Wood housing estate retained the old 1880s stables from Sans Souci and converted them into dwellings.

After buying it in 1996 from developer Sean Dunne, Cosgrave Brothers restored St Helen's House and built a substantial bedroom wing, creating a lovely hotel. The large field in front of the hotel is now public open space.

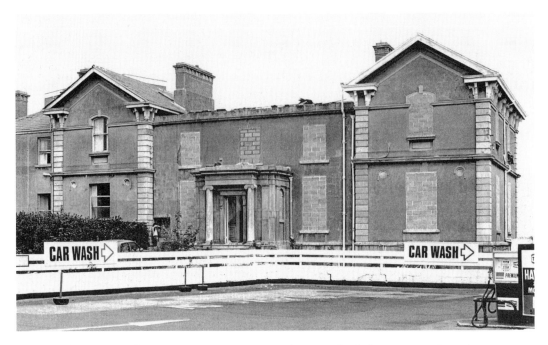

The front of the other Mount Merrion House on the N11 (divided into two residences), immediately to the south of the Stillorgan Park Hotel. (Courtesy of the Irish Architectural Archives)

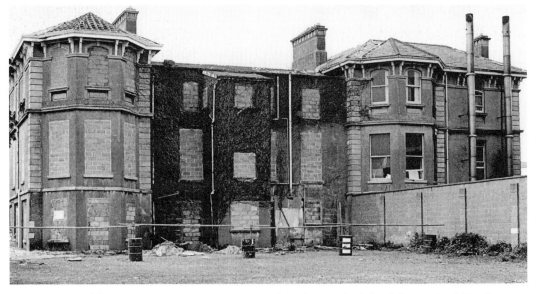

The rear of the other Mount Merrion House on the N11, south of the Stillorgan Park Hotel. (Courtesy of the Irish Architectural Archives)

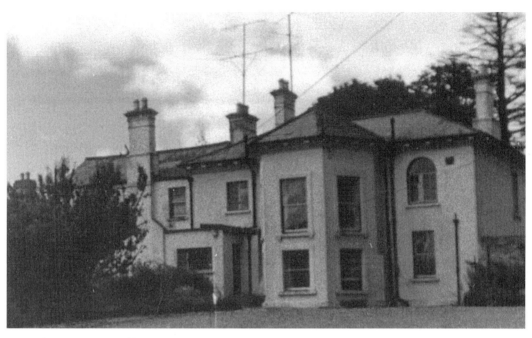

The rear of Fortwilliam House, at top of Mount Merrion Avenue.

The N11/Stillorgan Road in the 1970s, looking towards the city, at the junction with Mount Merrion Avenue. (Courtesy of Dún Laoghaire-Rathdown County Council)

The N11/Stillorgan Road in the 1970s, looking towards Stillorgan, at junction with Mount Merrion Avenue. (Courtesy of Dún Laoghaire-Rathdown County Council)

The hotel is well worth a visit, to admire the marble floors and walls in the foyer, the lavish ballroom and organ gallery, and to stroll down the terraced gardens on the east side of the house. The library, now called La Panto Restaurant, features two beautifully carved-oak fireplaces with copper overmantels depicting sailing ships, and beaten copper friezes. The Jacobean room on the first floor (over the porch) is also interesting for its military-style decorations on the panelled walls. There is a portrait of Gough in the foyer.

M.C. O'Sullivan offices, north of Ashurst Apartments, as seen from Shell filling station on the N11, 2005.

Demolition of M.C. O'Sullivan offices, 2005.

N11 junction with Mount Merrion Avenue, 2006. Ashurst Apartments on the right were built by P.V. Doyle for renting.

N11 looking towards Stillorgan, from Booterstown Avenue junction, 2007.

'Celtic Tiger' activity on the N11, 2007.

More 'Celtic Tiger' activity on the N11, 2007.

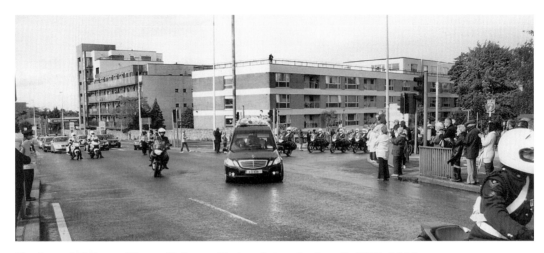

The funeral of Garrett Fitzgerald, former Taoiseach, travels along the N11, 2011.

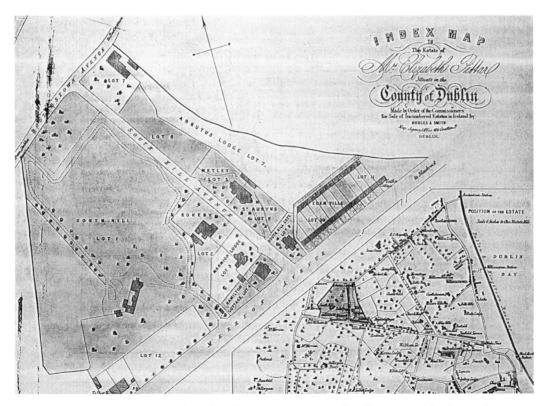

A map of Mount Merrion Avenue/South Hill Avenue, 1866. South Hill House and land is on the lower left. (Courtesy of the National Archives)

South Hill

In 1959, the Dominican nuns acquired No.123 Mount Merrion Avenue (better known as South Hill House, a late Georgian mansion on nine acres) to be used as a hall of residence for university students, in preparation for the impending move of UCD to nearby Belfield. The house they bought included a two-storey gate lodge, a two-storey gardener's house, a battery hen house, a cow house (two tyings), stables with five stalls, a two-car garage, and a walled garden with four large glasshouses, in addition to the usual tennis courts. The house was renamed Rosaryville. A new three-storey university hostel was added in 1965 and extended in 1968.

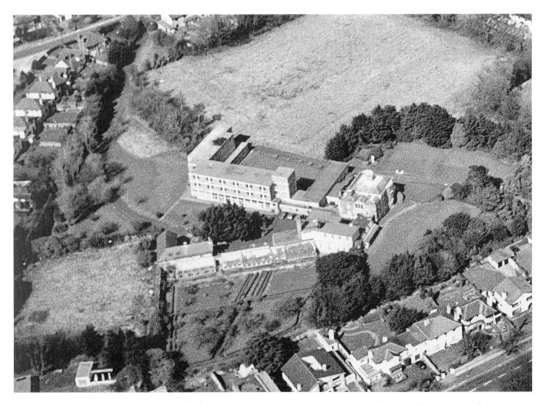

South Hill House, 1986 – also known as No.123 Mount Merrion Avenue. (Courtesy of Peter Barrow Aerial Photography)

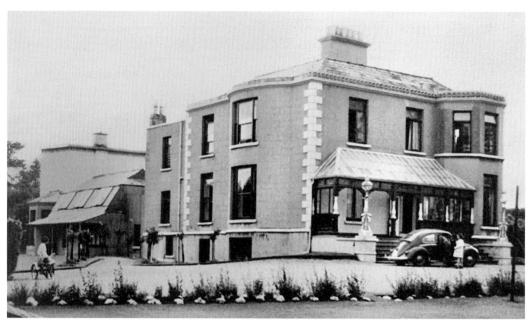

South Hill House in the time of the Dominican nuns. (Courtesy of Dominican sisters)

South Hill House Dominican nuns. (Courtesy of Dominican sisters)

In 1987, the entire property was sold, after which a developer demolished the modern block to make way for a nice estate of sixty town houses, while retaining the period house. South Hill is two storeys over a basement, with various large extensions. The stained-glass conservatory on the shallow first-floor return features portraits of three ladies and small birds – the latter are also included at the top of various front windows.

Mount Merrion Pitch and Putt Club

Very few people know about this nicely landscaped oasis behind the Stillorgan Park Hotel, accessed via a lane alongside No.7 Priory Avenue, but it is probably Mount Merrion's best-kept secret.

Stillorgan Priory was a grand Victorian house located roughly between the Pitch and Putt Club and Priory Drive. It may have taken its name from a real priory, since the 1837 Ordnance Survey map shows 'priory ruins' around the present Stillorgan VEC College on the old Dublin Road. In the mid-nineteenth century, the Sweetman family occupied the house; the Dudgeon family then occupied it from about 1872 to 1925, after which it was abandoned. The many gables on the house may have inspired the Keegan family to name their nearby house and farm The Gables.

Just after the Second World War (or the Emergency, as it was known in Ireland), various builders, including Sisk and McInerney, developed the Priory Housing Estate, leaving two acres, one rood and thirty-nine perches as public open space, which quickly became a dumping ground.

The church of St Thérèse in Mount Merrion was on the lookout for a site for tennis courts, and leased the open space in 1958 from Hardwicke Ltd. However, the cost of the project proved too high and the land was left idle. The Pope's Second Vatican Council, convened in 1962, advocated greater communication with the other Christian Churches (ecumenism). Hence, from 1964 onwards, the Catholics, Anglicans and Presbyterians around Mount Merrion, organised an annual golf outing to different clubs, such

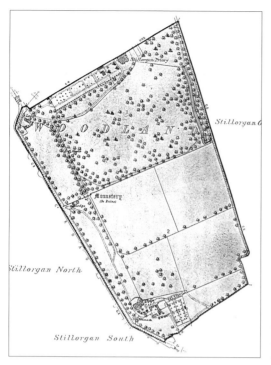

Map of Stillorgan Priory, 1881. (Courtesy of the National Archives)

Map of Thornhill estate, 1880. Lot 7 is Stillorgan village. (Courtesy of the National Archives)

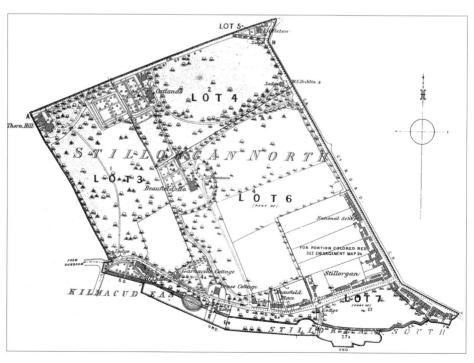

as the Grange in Rathfarnham and Foxrock. This led to the idea of a Pitch and Putt Club for the young people of Mount Merrion, and the Priory open space was chosen as the location. The land was cleared and landscaped, and the small pavilion built for meetings, mostly by voluntary effort, but with some fundraising. The official opening and Catholic blessing occurred in 1967, including an exhibition game by the Irene Club and CYMS organised by the Pitch and Putt Union of Ireland.

Thornhill House

This late-eighteenth-century house is situated on part of the former estate of the Earl of Carysfort, being part of a much larger parcel of land which included Thornhill, Oatlands, Beaufield and most of the village

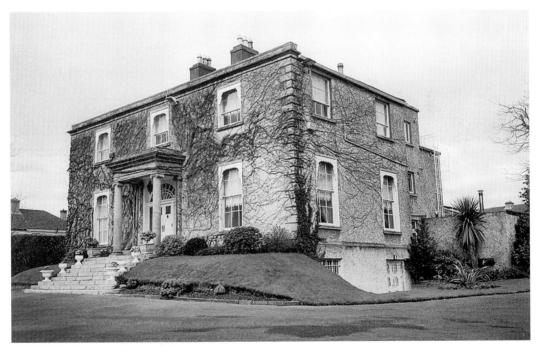

View of Thornhill House in Cherrygarth, 2006.

of Stillorgan, all let by Thomas Addis Emmet to William Fleming for ninety-five years from 1799. In 1880, the Landed Estates Court sold this entire parcel of land, which was at that stage owned by Richard Guinness Hill (deceased), and the particulars make very interesting reading. The parcel was described as 'all that part of Stillorgan, in the County of Dublin, formerly held by Robert Emmet, but now in the possession of said Thomas Addis Emmet or his under tenants, comprising by estimate forty-four acres, three roods and twenty-seven perches, etc.' (Sixty-three acres, three roods, and thirteen perches in statute measure.) Part of the annual rent included 'one fat hog' every Christmas. Robert Emmet was, of course, the Protestant patriot executed in 1803, at the age of twenty-five, after his unsuccessful uprising in Dublin.

Thornhill (Lot 3 on map, p. 110) comprised sixteen acres and had a gate lodge at the south-west corner, off the present Kilmacud Road. The occupiers also had a right of way along Callary Lane, through the north side of Oatlands, leading to the Stillorgan Road, at which there was another gate lodge beside Littleton.

Oatlands (Lot 4) comprised thirteen acres. Littleton was a small plot/house beside the east end of Callary Lane (the lane is still here, but overgrown).

Beaufield (Lot 6) was twenty-five acres, and included Garnaville Cottage and Ornee Cottage, along Kilmacud Road.

Stillorgan village (Lot 7) comprised eighteen acres, with a frontage to Stillorgan Road and Kilmacud Road, and included the cottages now known as The Hill. The Joly family leased various small pieces of land. The inhabitants of Stillorgan were entitled to draw water from the well at the south-east corner of the present shopping centre.

Within a few years of the 1901 Census, the property must have reverted to the landlord, since the Earl of Carysfort (of Glenart, County Wicklow) let it again for fifty years from 1908 to Thomas Talbot Power of Inverusk, Ballybrack, County Dublin. The lease comprised sixteen acres, twenty-two perches, including gate lodges, at an annual rent of £125. The Power

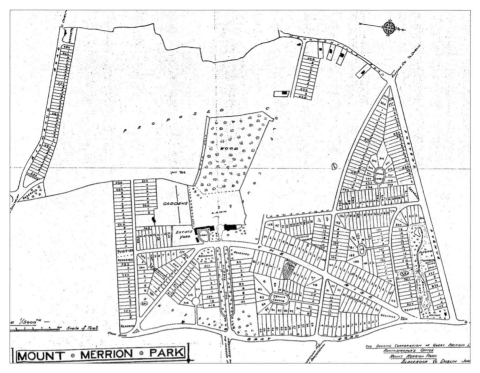

Proposed layout of Mount Merrion estate, 1928. (This was not the final layout.)

family were famous whiskey distillers based in Thomas Street (John's Lane) from 1791, and were the first company to sell their whiskey in miniature bottles, called 'Baby Powers'. The Powers were from Wexford and married into the Talbot family, also from Wexford. Sir Thomas Talbot Power died in 1930. In due course, the Ryan family became the leaders of the distillery. The company merged in 1966 with rivals, John Jameson & Son and Cork Distilleries Co., to form Irish Distillers. Bushmills in Northern Ireland joined the group in 1972. A new central distillery was built in Midleton, Cork, in 1975, and the various constituent plants closed. In 1988, Irish Distillers became part of Pernod-Ricard. The old John's Lane distillery in Thomas Street is now the National College of Art and Design.

In the 1930s, William Ryan, a nephew of Sir Thomas Talbot Power and co-director of John Power & Son Ltd, acquired Thornhill. One of his sons,

Clem Ryan, still fondly remembers his childhood in the house, including open fields all around, some with wheat growing, their hens and pigs, and their Jersey cows. He also remembers the 'Mass path' from their house to the nearby Mount Merrion House (by then a Catholic chapel), and also the deer, kept there on behalf of the Ward Union Hunt (North County Dublin).

Following the death of Philomena Ryan in 1959, the Ryan family sold a large part of Thornhill to P.V. Doyle, builder (and later hotelier), who immediately built the Cherrygarth estate of sixty houses, some two storey, but mostly bungalows. The original lodge on Kilmacud Road was demolished by the county council in the 1970s to allow road widening and a new bungalow was built further back from the road.

Mount Merrion Park Housing Estate

Thomas Joseph O'Neill bought the original 300-acre demesne from the Pembroke family in 1918, for £28,500, and sold it the following year to Thomas John Wilson for £36,000. Presumably, because of the War of Independence and subsequent Civil War, it wasn't until the mid-1920s that sites were sold to small builders and some bungalows were built on Mount Anville Road (roughly opposite the present Council Depot), Roebuck Avenue, Foster Avenue and St Thomas Road.

Sales were slow, however. In 1928, Wilson sold the demesne to Mount Merrion Estates Ltd for £15,000, plus £21,000 in charges (presumably a mortgage), and they appointed the Housing Corporation of Great Britain Ltd to produce a master plan for the entire estate (renamed Mount Merrion Park). This plan envisaged housing on the eastern half and a golf course on the western half, with the woods as a centrepiece. A marketing suite was set up in the north block of the stables, and the promotional brochure included the timetables for two bus services: one the United Tramways Co. Ltd to and from O'Connell Bridge, Dún Laoghaire, and Bray; the other the Robin Bus Co. to and from Burgh Quay and Foxrock.

In those days, Mount Merrion was also called Callary and was located in the half barony of Rathdown, County Dublin. However, it wasn't until Irish Homes Ltd appointed John Kenny & Sons as builders in 1933 that the estate began to develop in earnest. Kenny demolished the high stone wall that surrounded the demesne, excluding the four stone pillars and cast-iron gates and railings opposite the top of Mount Merrion Avenue. The first pair of houses was completed in 1934 (No.1 and No.3 Greenfield Road), proceeding

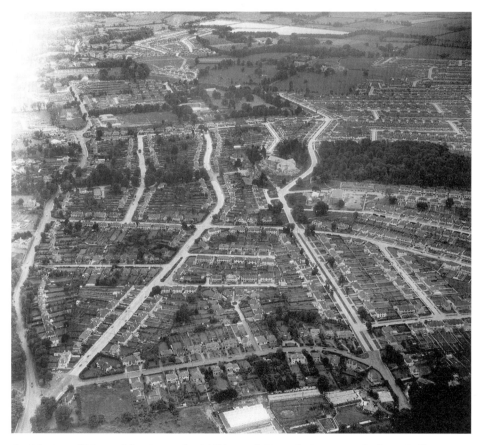

Aerial view of Mount Merrion in the 1950s, with Foster's Avenue at the base, Stillorgan Reservoir at the top, and Stillorgan Road/N11 along the left. Glenville Industrial Estate is in the centre at the bottom. Deerpark and the church of St Thérèse are in the centre right. Thornhill House grounds are visible near the centre rear (now Cherrygarth houses). (Courtesy of the National Library)

Art Deco ESB transformer station (1930s) in Sycamore Crescent.

to Sycamore Road, The Rise, Greygates, Trees Road Lower, The Close, and Chestnut Road over the next five years. The few shops on The Rise were built during this period, and also Estate Garage Ltd (1936) on the Stillorgan Road, which included a sweet shop and vegetable shop (now the Esso garage).

Irish Homes Ltd and its architect Rupert Jones knew that their houses would have to be special in order to attract buyers to this semi-rural location. They prepared a new estate plan, retained as many of the mature trees as possible, laid out very wide roads, provided long back and front gardens, and built a mix of three and four-bedroom houses. Some houses incorporated garages or, alternatively, space at the side was left for a future garage. The promotional brochure boasted a minimum of 110ft between the front of opposite houses, six houses to the acre, and fifty different house types. Most important of all: no two pairs of houses were exactly the same. Various little architectural features on different houses added diversity and

Architect Rupert Jones.

Builder John Kenny.

interest, such as some half-timbered facades, bay or bow windows, recessed porches (some arched), recessed balconies, overhanging eaves, gable and hip roofs, gambrel roofs, natural slates or plain concrete tiles on the roofs, porthole windows, coloured glass in lead in hall doors, red tile windowsills, etc. The crowning feature was probably the patterned render on the outside of all houses, covered with snow-white masonry paint.

The Kenny houses were sold for £750 to £1,150, depending on size and design, and held on 900-year leases for around £10 to £12 per annum ground rent.

Unfortunately, a six-month strike in the building industry forced work to stop in 1937, and this was followed by the Second World War, during which nothing was built. So ended Kenny's wonderful work.

Second World War bomb shelter in Greygates. It is 10ft high, about 7ft in diameter, and made with 1ft-thick concrete.

After the war, F.W. Wilson, son of the original purchaser of the demesne, and his partner, Mather, developed the Wilson estate, comprising Deerpark Road, Callary Road, Cypress Road, North Avenue, and, of course, Wilson and Mather Roads, named after themselves. They employed different builders, for example McNeill and Towey. A few houses at the bottom of North Avenue were built by someone else at the start of the war, when certain materials were in short supply. John du Moulin built some houses at the top of The Rise.

The 1950s saw more house building to the south of Deerpark, comprising Trees Road Upper, Redesdale Road, Thornhill Road, Clonmore Road, Cedarmount Road and Glenabbey Road, with different builders involved. The bungalows along Kilmacud Road were built at this time, although

four two-storey houses near the east end were built in 1932. Most of the post-war housing comprised smaller and less ornate dwellings, more suited to the needs of a depressed economy. Wilson and Mather had retained land after all the foregoing house building, since part of the present Deerpark was compulsorily purchased from them in the 1960s.

Merville House

This mid-eighteenth-century house is built on part of the original Fitzwilliam estate, in the old townland of Owenstown. When Jonathan Barker surveyed the townland in 1762, his map showed the seat of Anthony Foster, including a sketch of the front elevation of the house, with its two bay windows and a large walled garden some distance to the west of the main house (including its own small house). In later years, Foster became Chief Baron of the Irish Exchequer (a judge), and the road through the townland became known as Foster's Avenue.

By the time of the Tithe Applotment Survey in the 1820s, William Downes, the Lord Chief Justice, was in occupation of Merville House. In 1830, it was recorded that Downes was the lessor but had sublet to Michael Sweetman, and the forty-nine-acre estate included farm buildings and a school house. Lieutenant General Henry Hall was in residence for many decades in the nineteenth century. The last important occupant in the first half of the twentieth century was the Hume-Dudgeon family, who in later years operated a riding school in the field alongside the Stillorgan Road.

UCD bought the house and sixty acres in 1953 for £100,000, as part of a land bank for a future campus. After refurbishment, all research work in biochemistry was moved to Merville from the North Block, Earlsfort Terrace. The college again refurbished and extended the house in 2003, including the two original wings and courtyards, and it is now occupied by Nova UCD, a research facility.

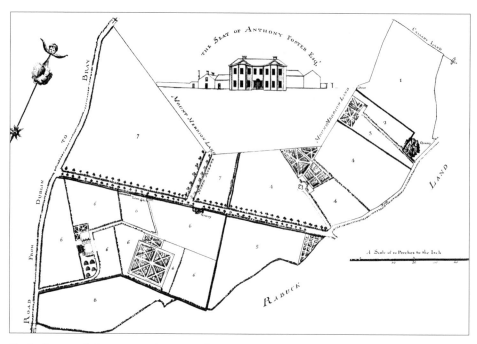

Barker's map of Owenstown (1762), showing Merville House and walled garden at the bottom left. The road running left to right became Foster's Avenue. (Courtesy of the National Archives)

The walled garden of Merville House became a UCD football stadium, but is now the site of a science building.

Internally, all the fireplaces are gone, but there are still some delicate plaster cornices and centrepieces, and some lovely moulded door architraves, in addition to a curved panelled door between the east and west hall. On the front elevation, a noteworthy feature is the cantilevered sandstone balcony, with cast-iron balustrade, running the full width of the house. Until recently, the original walled garden was called Belfield Park and was used jointly with the Football Association of Ireland as a soccer stadium. Now a brand-new building occupies the site, used by the National Institute for Bioprocessing, Research and Training. Two original rubble granite walls survive from the walled garden, as well as a brick wall.

Roebuck Castle

Ball records that Baron Trimleston, an officer in the Confederate Army, occupied Roebuck Castle, but that it was destroyed in the 1641 Rebellion. The Down Survey of the 1650s reported that there was a castle in Roebuck 'in repair', and that Baron Trimleston, Irish Papist, was the owner (including 500 acres). The family name of Barnewall is probably more familiar, and was famous in legal circles for many generations. Around 1790, Lord Trimleston repaired the castle, and hence it looks very majestic in the picture painted in 1795 and included in Ball's *History of County Dublin*.

James Crofton acquired the property around 1800 and practically demolished and rebuilt the castle. Crofton Road in Dún Laoghaire commemorates the man, since he was one of the original commissioners appointed to organise the construction of the new harbour (*c*.1818). By the 1860s, the Westby family were owners, and by 1870, they had carried out extensive alterations and improvements, including rebuilding the out-offices around the courtyard.

Roebuck Castle and seventy-two acres was bought by the Little Sisters of the Poor in 1943, for £16,100. The castle contained six bedrooms, a dining

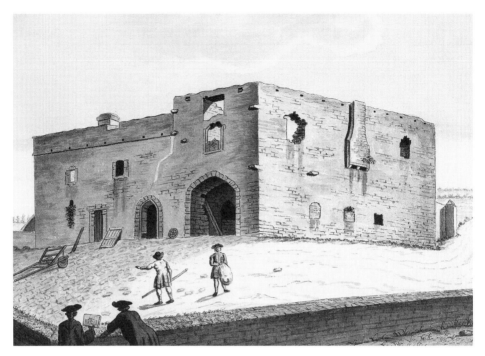

Roebuck Castle (1765), *by Gabriel Beranger. (Courtesy of the National Library)*

room, drawing room, ante-room, three sitting rooms, five maids' rooms, servants' hall, two bathrooms, kitchen, scullery, and pantry. There was stabling for sixteen horses and tyings for twenty cows, in addition to a walled garden with glasshouses. Two cottages and a gate lodge were included. Alongside the old castle, the nuns built a nursing home, including a separate church, to cater for about 100 elderly residents. The nuns were self-sufficient with their farming activities, including rearing sheep and cows.

In 1986, the nuns sold the castle itself and ten acres to UCD for £750,000. The beautiful two-storey stone gate lodge on Roebuck Road, built in 1872, was sold off separately around the same time. It has been nicely extended in recent years, and still bears the Westby coat of arms.

Initially, UCD established the Michael Smurfit Graduate School of Business in Roebuck Castle and converted the more modern nursing home into student residences. The business school moved to the former

Map of Roebuck, 1866. (Courtesy of the National Archives)

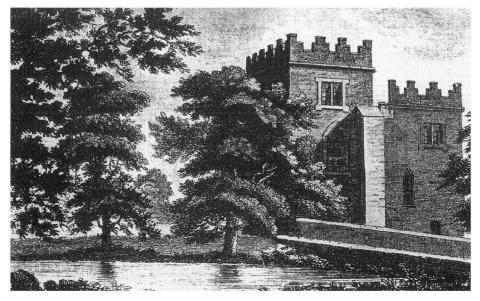

View of Roebuck Castle (1795), part of which is incorporated into the present building.
(From Ball's History of County Dublin*)*

Carysfort Training College in 1991, and the Faculty of Law now occupies the castle, where the former church has been converted into a large ramped lecture theatre.

Most of the present exterior of Roebuck Castle is rendered, but there are large amounts of sandstone dressings around windows, and the west bay window is completely clad with sandstone. The three-bay arcade under this bay window is unusual and may have been part of the original structural buttresses of the castle. Internally, many of the rooms, especially at first-floor level, have attractive plaster cornices and marble fireplaces, and some rooms are embellished with slender green and red marble columns. The pine staircase balustrade is noteworthy, as is the ramped hooded fireplace in the small entrance hall.

Little Sisters of the Poor/Hermitage

These French nuns were founded in 1840 by Jeanne Jugan (recently canonised), to cater for elderly poor, and came to Waterford in 1871, and Kilmainham, Dublin in 1881. By 1943, the nuns decided to build another house for the poor aged, and acquired Roebuck Castle and a large farm. The previous year, the adjoining Hermitage House in Roebuck Road was put up for sale by Frances Mansergh (also known in the operatic world as Fanny Moody) and the nuns purchased the house and seventeen acres as a Novitiate. They immediately built a chapel, but it wasn't until 1949 that the rear three-storey Novitiate was finished.

In 1986, the nuns sold their Roebuck Castle Nursing Home to UCD and then built the five-storey Holy Family Residence in the grounds of Hermitage.

The main block of the Hermitage appears to be early nineteenth century, being three storeys over a basement and three bays wide. The original house may have been rectangular in plan, but around the middle of the nineteenth century was possibly extended to the rear, creating a more

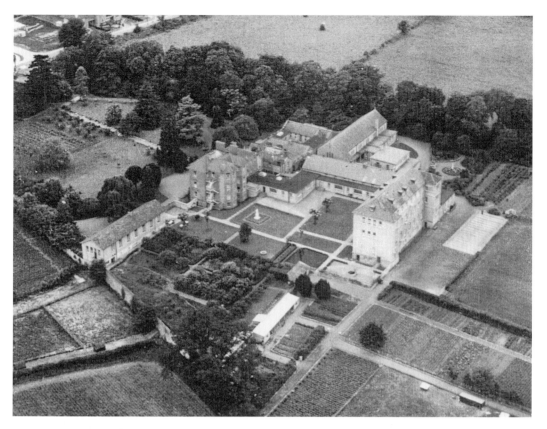

Hermitage/Little Sisters of the Poor on Roebuck Road. The main old house is in centre left of the group, and the Novitiate was the high rear block. (Courtesy of Little Sisters of the Poor)

square-shaped building. Certainly the exceptionally thick spine partition gives the impression that there might be two walls here. Various other wings were added over the years. Internally, most rooms on all floor levels have ornate cornices and moulded door architraves. The two interconnecting rear first-floor rooms would have made a fine ballroom at one stage, greatly enhanced by the mock pillars and elaborate moulded architraves around the central opening.

Knockrabo

This seven-bay, two-storey-over-basement late Georgian mansion, on twenty-two acres, was better known as Mount Anville House (although sometimes called Mount Anville Park), and its most famous owner was Christopher Palles, who was Lord Chief Baron of the Court of Exchequer (he would nowadays be called the President of the High Court) from 1874 to 1916. He bought Mount Anville House in 1885 and died there in 1920. The house had a feature veranda at ground-floor level for the full length of the rear elevation and the end elevations. There was also a viewing tower in the centre of the roof.

The Protestant secondary boarding school PNEU acquired the property in 1942. The Parents' National Education Union was founded in Chichester, England by educationalist Charlotte Mason (1842-1923). The Irish principal was Mrs J.H. Waller and the school catered for female boarders, in addition to a day school for young boys and girls. The girls wore a light-blue uniform and attended religious services in nearby Taney church. The house name was changed to Knockrabo (Cnoc or hill of Roebuck), in order to avoid confusion with Mount Anville Convent across the road.

The school lasted until 1957, when it was sold to the Dublin Gas Company Sports Club. The club had a pitch and putt course, a bowling green, tennis courts, and football pitches, and the maintenance staff were provided with apartments in the old house and the two gate lodges. The Ski Club of Ireland was founded in 1963, and for a few years it sublet part of the Gas Company grounds, running its first slope here. They moved to Kilternan when Knockrabo was sold to Bank of Ireland.

The Gas Company sold the property to the Bank of Ireland Sports Club in the mid-1970s, and the bank demolished the old house and outbuildings. The bank acquired the adjoining, smaller Georgian house Cedarmount (once called Mount Anville Cottage) in 1988, and later sold it. The combined property of twenty-four acres was sold in 1999 and awaits redevelopment.

OTHER BOOKS BY THE AUTHOR

Other titles published by The History Press Ireland

Harold's Cross
JOE CURTIS

Today Harold's Cross is a bustling thoroughfare, and although it is now a suburb on the south side of Dublin, it was once akin to the best little town in Ireland, being completely self-sufficient, with schools, churches, shops, pubs, hospital, orphanage, convents, monastery, cinema, a major cemetery, mills and factories, park, canal, large and small houses, dog track, barracks, and many farms and orchards. For its residents, it has a rich and varied history, which is beautifully captured in this book of archive photographs.

978 1 84588 702 5

Rathmines
MAURICE CURTIS

From the Battle of Rathmines in the seventeenth century (that changed the course of Irish history) to the achievements of Irish Independence and beyond in the twentieth century, Maurice Curtis charts the development of this nationally important suburb of Dublin that mirrors the changing face of Ireland itself. Illustrated with over 150 archive photographs, this fascinating book pays fitting tribute to the place Rathmines has carved in the history of all who have passed through it.

978 1 84588 704 9

Portobello
MAURICE CURTIS

In this book, Maurice Curtis, takes the reader on a visual tour of Portobello through the decades, recounting both the familiar and the events and places that have faded over time, revealing many fascinating details, including the fact that Dublin's Portobello was named after an area on the East Coast of Panama! This, and much more, is captured in a timeless volume, which pays fitting tribute to this well-loved part of the city.

978 1 84588 737 7

Dublin Folk Tales
BRENDAN NOLAN

Have you heard the story of 'Bang Bang' Dudley, who roamed the streets of Dublin shooting anyone who caught his eye? Do you know who the real Molly Malone was, or the story of Marsh's Library, or how the devil himself came to the Hellfire Club? These and many more accounts of Dubliners and Dublin City fill this book, as told by Brendan Nolan, a professional storyteller who has been recording these tales for decades.

978 1 84588 728 5

Visit our website and discover hundreds of other History Press books.

www.thehistorypress.ie